Lost Attractions

of

ALABAMA

Lost Attractions

of

ALABAMA

TIM HOLLIS

THE
History
PRESS

Published by The History Press
Charleston, SC
www.historypress.com

Copyright © 2019 by Tim Hollis
All rights reserved

First published 2019

Front cover, top left: author's collection; *top center*: Steve Gilmer collection; *top right*: Steve Gilmer
collection; *bottom*: author's collection.
Back cover: Alabama State Archives collection; *top insert*: author's collection; *middle insert*:
author's collection.

Manufactured in the United States

ISBN 9781467141208

Library of Congress Control Number: 2018966268

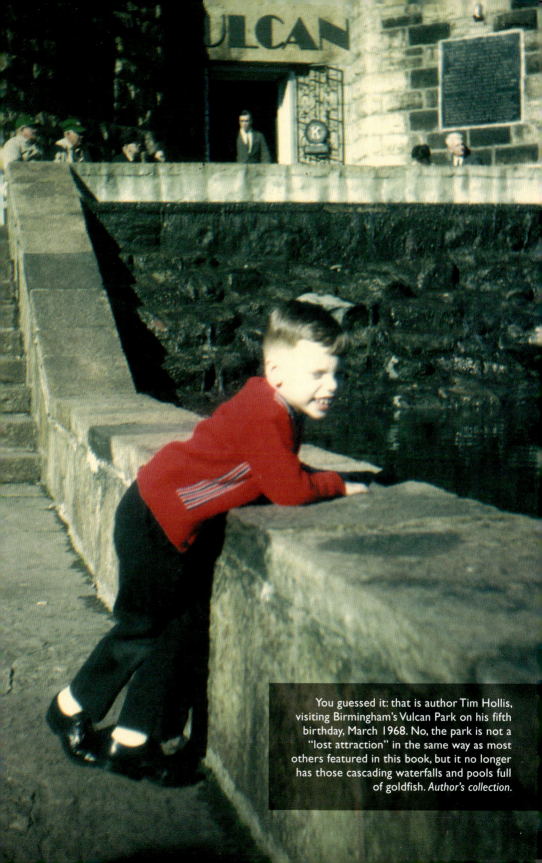

You guessed it: that is author Tim Hollis, visiting Birmingham's Vulcan Park on his fifth birthday, March 1968. No, the park is not a "lost attraction" in the same way as most others featured in this book, but it no longer has those cascading waterfalls and pools full of goldfish. *Author's collection.*

CONTENTS

ACKNOWLEDGEMENTS

Although most of the material you will see in the pages that follow originated in my own decades-long collection of memorabilia, credit must be given to the additional sources that enlivened the result. As you will notice in the credit lines for the photos, a number of them came from fellow Alabama collectors and photographers: Gord Booth, Mike Cowart, Cariss Dooley, Lance George, Steve Gilmer, Dean Jeffrey, Kelly Kazek, Warren Reed, Michael Smith, J.D. Weeks and Russell Wells. Further archival help was provided by Meredith McDonough of the Alabama State Archives, Christie Shannon of the Gulf Shores Museum and John Varner of the Auburn University Archives. We must also mention the late photographer John Margolies, who bequeathed his personal archive to the Library of Congress with the amazing stipulation that no restrictions were to be imposed on its use by other authors and researchers. Finally, special photography for some of the relics was provided by David Pridemore.

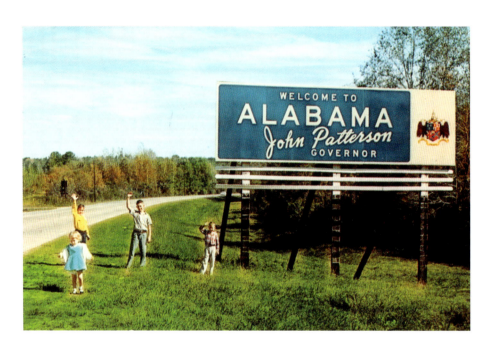

These billboards greeted inbound Alabama tourists on each of the major highways, circa 1960. Trying to determine the location of this one has prompted lively debate among roadside history enthusiasts, with no conclusive decision. Several points have been ruled out but none found that exactly match the visible terrain and surroundings. *Author's collection.*

INTRODUCTION

Welcome, friends, to the latest volume in the ongoing "Lost Attractions" series. For those who are new in this neighborhood, perhaps it would be best to begin by explaining the title. Just what is a "lost attraction" of Alabama anyway? Well, it is very simple. A lost attraction can be any type of tourism-related business—roadside attraction, motel, restaurant or other—that no longer exists. Casually flipping through the pages, one might conceivably run across an image and comment, "Hey, that place is still there!" That would bring us to the secondary definition: a business that has changed radically over the years and no longer resembles its depiction in vintage photos and postcards, even though, technically, it may still be operating. Everything clear now?

One thing this book is *not* is a history of Alabama tourism. The History Press and I have already done that story, back in 2013. That book, *See Alabama First*, is still readily available and is highly recommended by this very same author. This volume, however, concentrates solely on things that have disappeared—and that actually proved to be a bit more difficult than I anticipated at the beginning.

Alabama has had an amazing success rate when it comes to tourist attractions. Some of the major ones, such as Bellingrath Gardens and Ave Maria Grotto, date to the early 1930s, and not only have they thrived ever since but also have changed so imperceptibly that there is no point in comparing the present day to vintage photos. They look exactly the same. There are many other attractions not nearly as old that continue to draw

crowds, such as the Space and Rocket Center in Huntsville and the rocky acreage of Horse Pens 40. Many times during the process of assembling this book, I came across a great photo but, upon further research, found that the attraction or business is still in operation. If, in perusing the pages that follow, you come across a sight that was erroneously thought to be defunct, comfort yourself with the idea that all efforts were made to verify if it still existed.

But never fear, the Alabama roadsides are still littered with the decaying corpses of businesses that were once viable, but their intended audience either dried up or moved away (as usually happens when an interstate replaces an older U.S. highway route). We will revisit dozens of them before we are finished, and for your traveling comfort, we have divided Alabama into three sections: northern, central and southern. The introduction to each section will give you a description of what is to be covered.

And now it is time to begin the ride. Some of our stops will seem like old friends, while others will be new to you—and some of them may leave you scratching your head as you try to figure out whoever thought they were a good idea. Everyone, try to stay together and don't lag behind. You're sure to see something unforgettable…no matter how hard you may try to forget it!

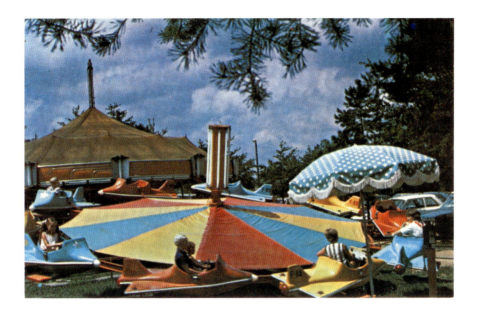

OPPOSITE, TOP: One of the most fondly remembered of any of the defunct Alabama attractions is Canyon Land Park, a collection of amusements on the rim of Little River Canyon near Fort Payne. The main feature was its chairlift ride fifteen hundred feet down to the very bottom of the gorge. *Steve Gilmer collection.*

OPPOSITE, BOTTOM: Canyon Land Park opened to much fanfare in March 1970. Its publicity made it sound comparable to Disneyland or Six Flags Over Georgia, while the reality was slightly less impressive. It still managed to draw crowds, however, due mainly to its novelty and scenic mountain location. *Author's collection.*

ABOVE: The Canyon Land property was strewn with traditional amusement park rides, some of which looked as if they had already been part of traveling carnivals for several years. Other features included a miniature train and a zoo that grew to include some one hundred animals. *Alabama State Archives collection.*

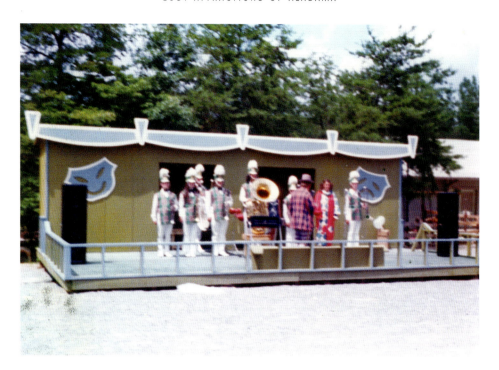

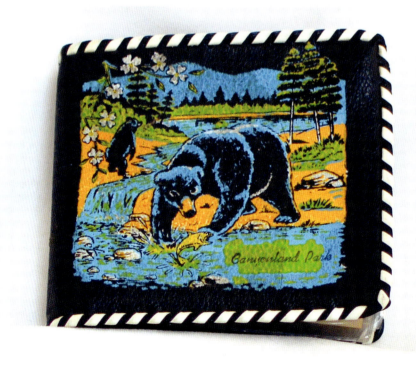

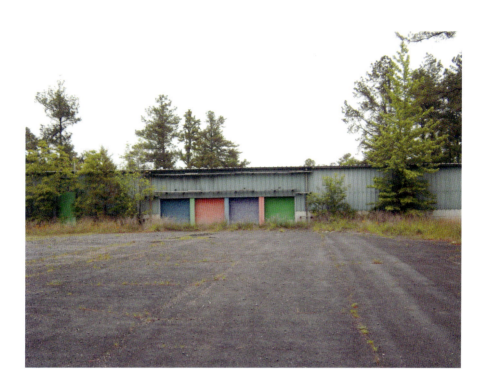

OPPOSITE, TOP: This was Canyon Land Park's small stage, where a vaudeville-type comedy show would be presented several times during the day. Also appearing regularly was a local Fort Payne band that would later win international fame as the superstar musical group known simply as Alabama. *Author's collection.*

OPPOSITE, BOTTOM: Like any good tourist attraction, Canyon Land Park had its own line of souvenirs. One strongly suspects that this child's wallet (the author was the child in question) originally was designed to be sold in Gatlinburg or Cherokee, but the park finagled a supply of them for its own name to be imprinted thereon. *Author's collection.*

ABOVE: Despite its novelty, Canyon Land Park closed around 1979–80, mostly due to a dispute with the state over the property at the bottom of the chairlift. This is how the former entrance gate—the same one seen in the earlier black-and-white photo—appeared in 2012, standing forlornly next to its weedy and overgrown parking lot. *Author's collection.*

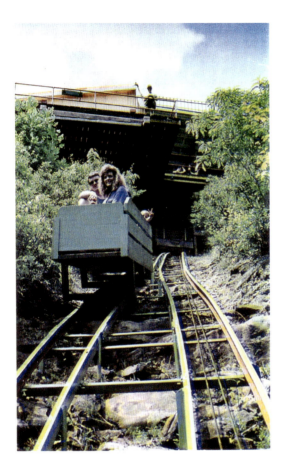

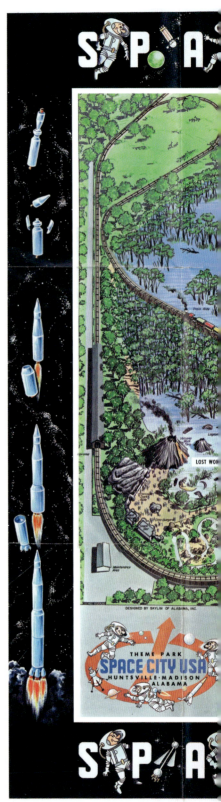

ABOVE: At Hurricane Creek Park, on U.S. 31 north of Cullman, there was no chairlift, but visitors could ride a small incline railway into the canyon. Now that Hurricane Creek is a city park instead of a commercial attraction, the incline is gone and hiking is the only method of getting around. *Lance George collection.*

RIGHT: Can it be classified as a "lost attraction" if it was never built in the first place? That is the question when it comes to Space City USA, which was supposed to have opened near Huntsville in 1965. This park map is particularly impressive when one realizes that the whole thing existed only in some promoters' imaginations. *Lance George collection.*

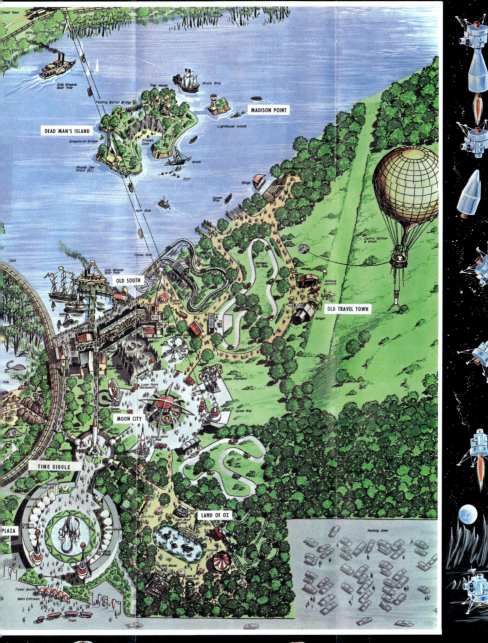

ABOVE: One of the few Space City USA features that made it into the early stages of construction was its Flintstones-inspired "Cave Man Car Ride," seen in the lower left-hand corner of the park map. What was intended to be its winding concrete pathway still exists as part of the Edgewater Recreation Center, the current occupant of the nonexistent theme park's property. *Lance George collection.*

OPPOSITE: After more than fifty years, it is understandable that remnants of the failed Space City USA project turn up quite rarely. Historian Lance George discovered this former sign rusting in a shed, along with a few other pieces that had been removed from the property decades earlier. *Lance George collection.*

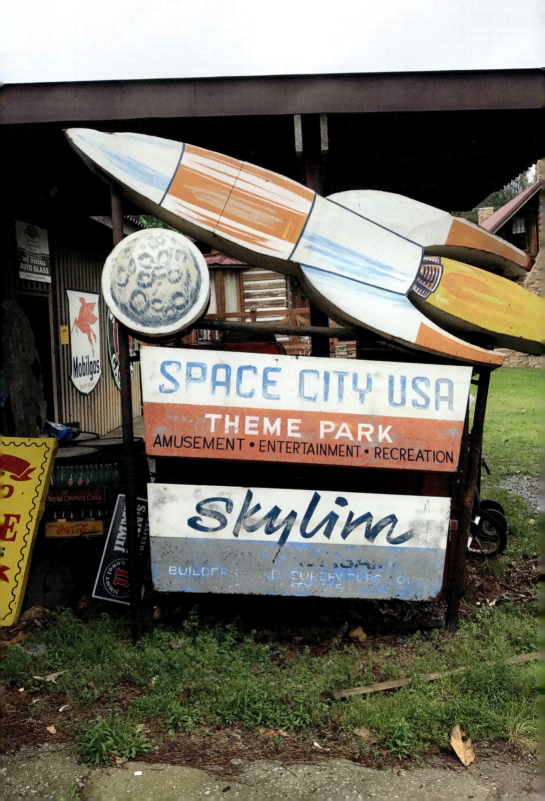

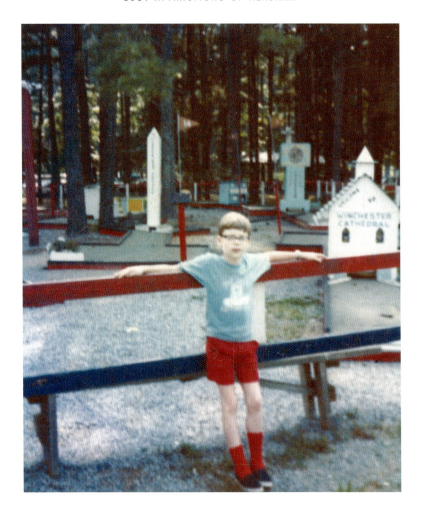

ABOVE: Years before the city of Cullman took over Hurricane Creek Park, it was operating Sportsman's Lake Park. This was the park's original miniature golf course in 1974, with the author doing preliminary research for this book. *Author's collection.*

OPPOSITE, TOP: Winkle World was another minipark, near the bluff of the Tennessee River at Sheffield. Besides miniature golf, Winkle World also had bumper boats and a go-kart track, all of which have now been bulldozed. So, if you happen to see a stray purple elephant roaming the neighborhood, you will know where it came from. *Author's collection.*

OPPOSITE, BOTTOM: Very little has changed at Gadsden's Noccalula Falls Park in the past sixty-something years since its opening, but this snack bar is one of the sights that can no longer be seen. Maybe too many people wondered what a "Noccalula Nik-Nak" was, because the spot is now home to an outlet of Alabama's ubiquitous Jack's Hamburgers chain. *Author's collection.*

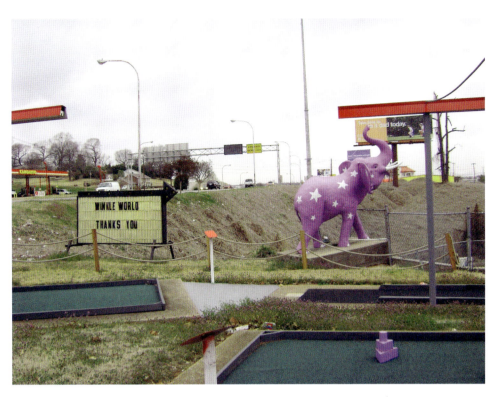

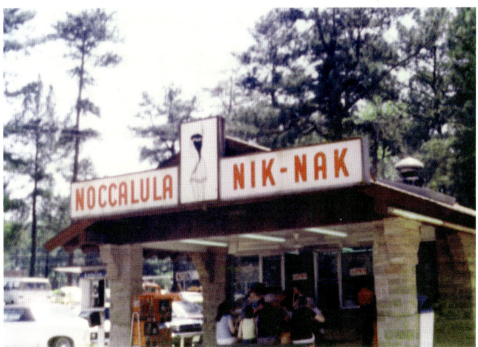

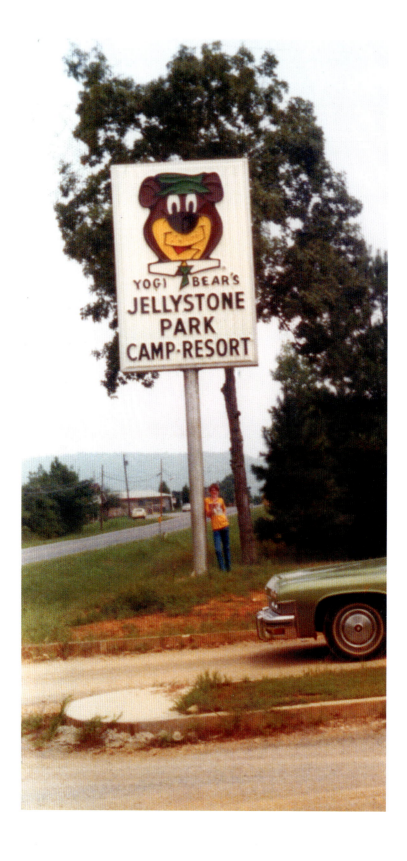

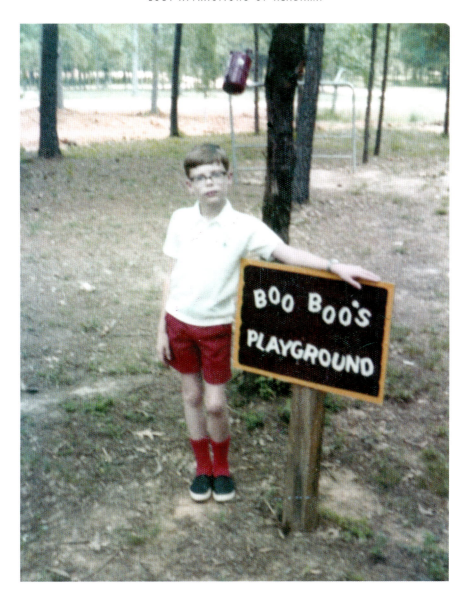

The national chain of Yogi Bear's Jellystone Park Campgrounds pitched its tent next to Lake Guntersville in the early 1970s. The campgrounds strove mightily to be small theme parks, with miniature golf, playgrounds, a large line of Yogi Bear souvenirs and twilight outdoor screenings of the classic Hanna-Barbera cartoons. The site is still a campground, but Yogi and Boo Boo packed up their pic-a-nic baskets and went into hibernation long ago. *Both, author's collection.*

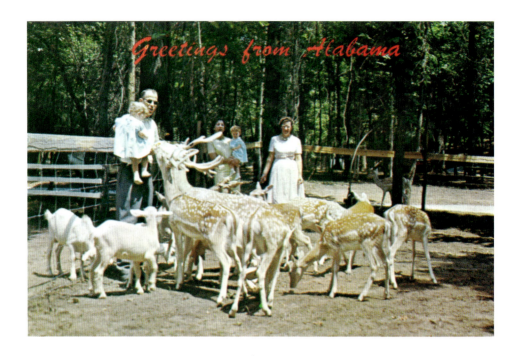

Some attractions disappear without leaving any evidence that they ever existed. Such is the case with the Muscle Shoals Deer Forest, on Brighton Avenue adjacent to Jaycee Park (which also apparently no longer exists). It featured large nursery rhyme dioramas in addition to its petting zoo. Research shows another Deer Forest, with many of the same sights, once existing in Michigan, leading one to conclude that they probably had common ownership. *Both, author's collection.*

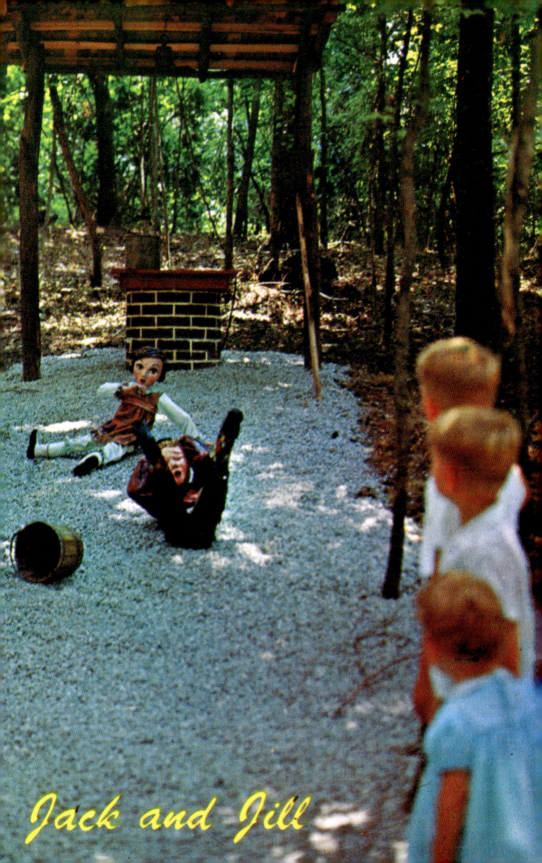

Jack and Jill

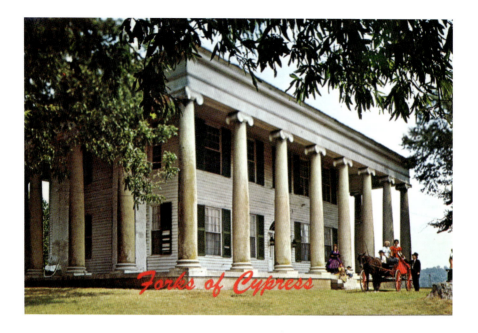

ABOVE: Alabama has many restored antebellum mansions, and quite a few of them are still drawing crowds today. One exception is Forks of Cypress in Florence, which was a popular attraction until it burned in 1966. However, tourists can still visit its columns—the only parts of it left standing. *Steve Gilmer collection.*

OPPOSITE: In recent years, there has been much controversy over what to do with monuments to the Confederacy. But long before that, many Alabama attractions proudly used Confederate imagery, and little doubt was left as to which side sympathies were expected to rest. *Both, author's collection.*

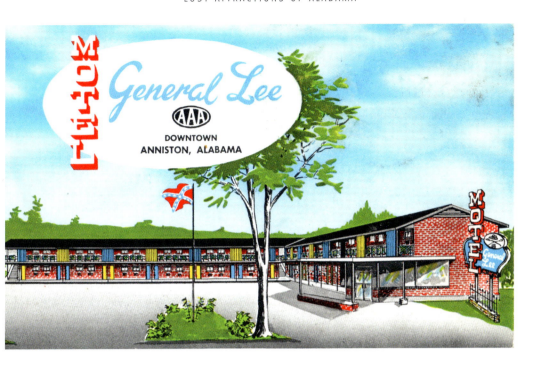

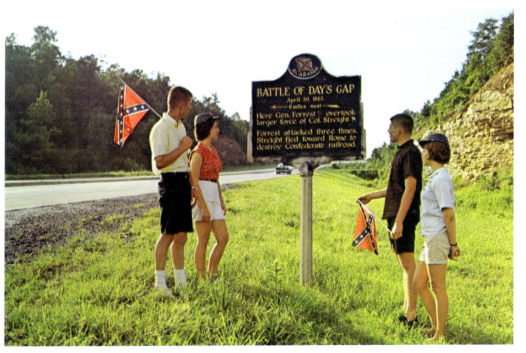

The Incident At LOONEY'S Tavern ©

1994 SEASON
CIVIL WAR MUSICAL DRAMA

A different point of view was presented in the outdoor drama *The Incident at Looney's Tavern* on U.S. 278 near Double Springs. It told the story of how Winston County refused to secede from the Union along with the rest of the state; however, the artwork on this souvenir program still reminds one of *Gone with the Wind* more than anything else. *Author's collection.*

The outdoor amphitheater and the *Looney's Tavern* musical were only part of an entertainment complex that included a paddleboat ride, restaurant, gift shop, indoor theater and the Looney Putt miniature golf course. Today it all sits abandoned behind a locked gate, as much a historical footnote as the "Free State of Winston." *Author's collection.*

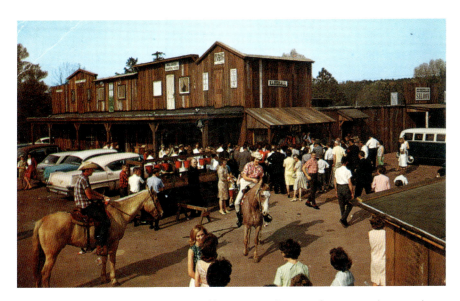

Even Confederacy-obsessed Alabama could not escape the craze for western theme parks that swept like a dust storm over many other states in the 1950s and '60s. Dry Gulch Ghost Town could be found on U.S. 31 at Gardendale, built around the obviously popular Grub Stake Restaurant. *Author's collection.*

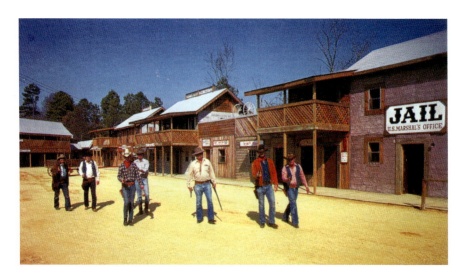

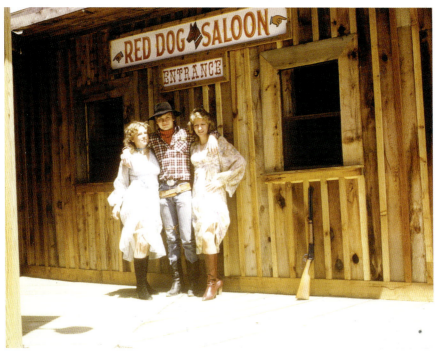

Several years after the western parks' popularity had dried up like a water hole, Legiontown USA opened on U.S. 11 near Steele in 1980. Despite grandiose plans that called for adding a roller coaster and log-flume ride, among other amusements, Legiontown's cowboys, outlaws and saloon girls had packed up their valises and vamoosed by the end of the decade. *Author's collection.*

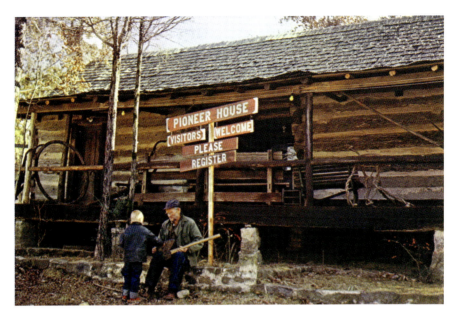

In 1963, Moulton pharmacist Hudson Sandlin established what he called the "Pioneer Homestead" alongside the highway that cut through the foliage of Bankhead National Forest. In the reconstructed log cabin, tourists could see how the early settlers of that part of the state made their living. *Author's collection.*

Technically, the community where the Pioneer Homestead was located was called Hepsidam. No such place exists on today's maps, and the site of this attraction is currently undocumented. Besides the homestead, the only other thing in Hepsidam was a general store, which is said to have attracted as many as five hundred visitors in a day. *Author's collection.*

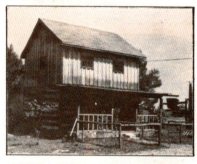
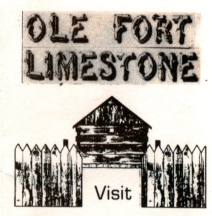

Another pioneer-themed park was Ole Fort Limestone near Athens. Much larger than the single-home homestead at Hepsidam, Ole Fort Limestone was an entire village of rustic buildings. After the park closed, some of those buildings remained as part of a roadside flea market, but like so many others, it has now vanished without a trace. *Author's collection.*

The American Cowboy Heroes Museum opened in Boaz in 1986 to display the collection of Western memorabilia owned by movie buff Jesse Rush. At the grand opening, comedian and former Gene Autry sidekick Pat Buttram was on hand to greet fans. The museum lasted only a few years, and today even Boaz's seemingly indestructible collection of outlet stores appears to have rung up its last sale. *Author's collection.*

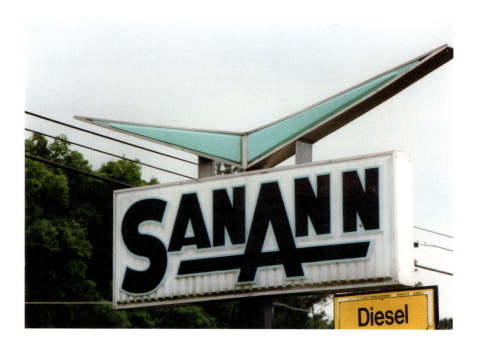

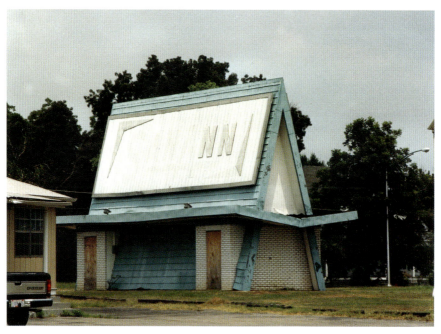

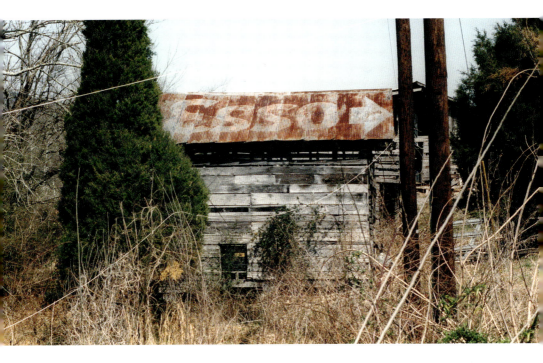

OPPOSITE, TOP: Travelers who were visiting all of these now-gone attractions had to keep gas in their jalopies, Jeeps and Cadillacs, and Alabama had plenty of homegrown SanAnn service stations spread across the state to keep them well supplied. *Author's collection.*

OPPOSITE, BOTTOM: The two most readily identifiable symbols of the SanAnn chain were its trademark aqua color and the omnipresent boomerang shape. Those two elements make even an abandoned SanAnn structure immediately recognizable. *Author's collection.*

ABOVE: Of course, there were plenty of other chain gas stations ready to fill empty tanks. This shed with its fading Esso sign stood near the entrance to Sequoyah Caverns in 1991; there was no visible trace of the building to which it was pointing, and today, even the sign is gone. *Author's collection.*

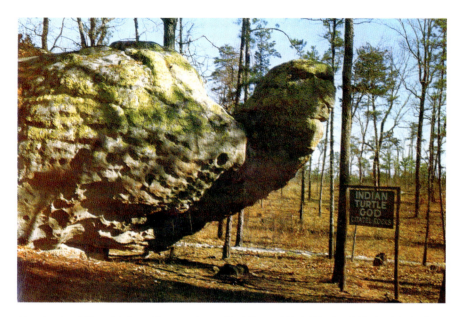

Atop Lookout Mountain's southern end near Fort Payne, Citadel Rocks did its best to look as much as possible like its more famous stony cousin, Rock City Gardens, at the mountain's northern terminus near Chattanooga. But even Rock City could not boast of having a gigantic stone turtle. *Author's collection.*

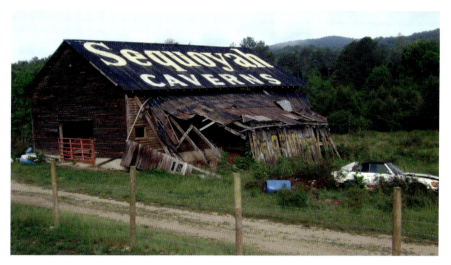

Sequoyah Caverns, on U.S. 11 at Valley Head, was opened in 1964 by Clark Byers, the longtime painter responsible for Rock City's barn roof signs. This barn had a Rock City sign on one side and a Sequoyah sign on the other. On the crumbling shed, notice the remnants of Byers' slogan, "World's Ninth Wonder." Out of loyalty, he refused to duplicate his longtime employer's claim that Rock City was "World's Eighth Wonder." *Author's collection.*

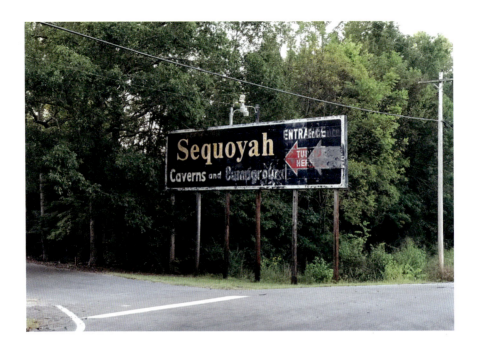

Clark Byers had certainly learned plenty about showmanship from his nearly thirty years of association with Rock City, and he made sure to retain his good relationship with the Lookout Mountain attraction. After Byers was electrocuted by low-hanging power lines while repainting a Rock City billboard in 1968, the company assumed control of Sequoyah Caverns during his recuperation. **ABOVE:** *Russell Wells collection*; **BELOW:** *Steve Gilmer collection*.

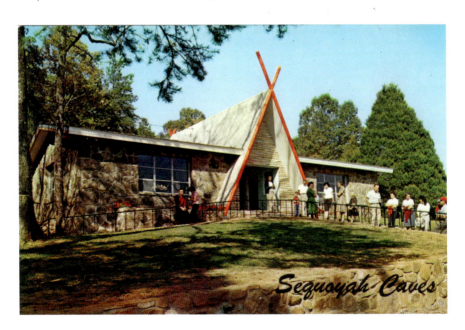

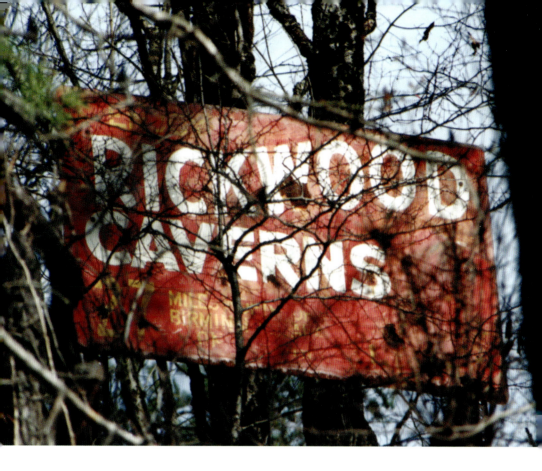

Until it became an Alabama State Park in 1974, Rickwood Caverns blanketed the northern third of the state with these red-and-white billboards. This one survived until the mid-1990s on U.S. 31 at Fultondale, but if any others happen to still be standing, by now they must have rusted beyond all recognition. *Author's collection.*

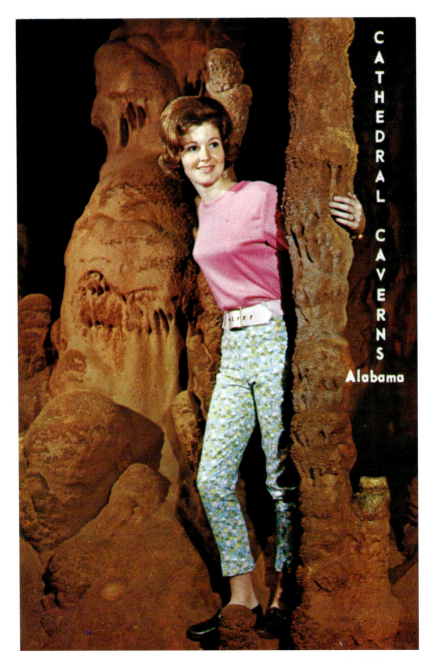

Cathedral Caverns, near Grant, also started as a commercial attraction (in 1959) and later joined the ranks of state parks (in 2000). Those who lived through the 1960s will certainly recognize this apparel: matching (or mismatching) flowery pants with a hot pink sweater. *Steve Gilmer collection.*

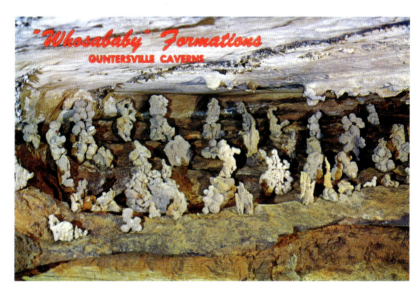

One underground attraction that did not become a state park—at least as of this writing—was Guntersville Caverns. Its advertising made much out of these unusual calcite formations, dubbed "Whosababies." With every cave looking a whole lot like all the others, each had to come up with some sort of selling point to set it apart from the rest. *Author's collection.*

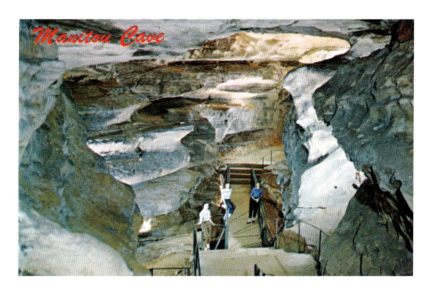

Manitou Cave, in the mountainous northeastern part of Alabama, distinguished itself by using only white light, instead of multicolored lights, to illuminate its formations. Although closed to commercial traffic years ago, spelunkers are now allowed to explore the passageways by appointment. *Steve Gilmer collection.*

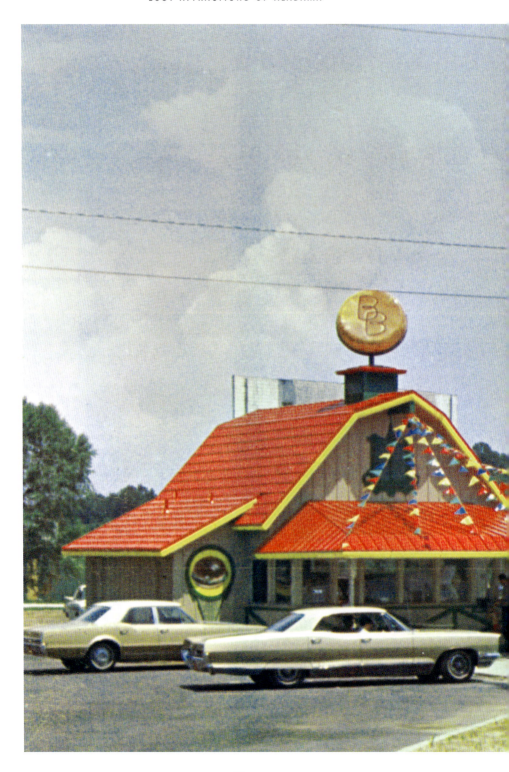

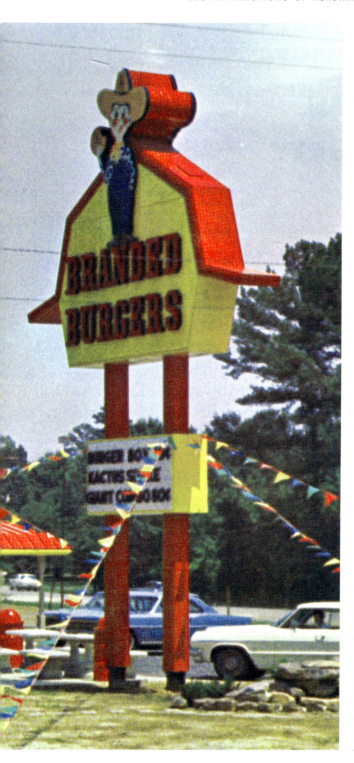

There were a number of Alabama restaurants—chains and otherwise—that came and went. Branded Burgers opened several locations in the northern part of the state. As this photo shows, its most identifiable architectural feature was the giant fiberglass hamburger rotating above the roofline. *Author's collection.*

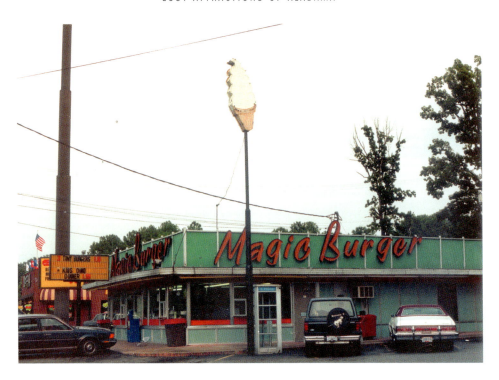

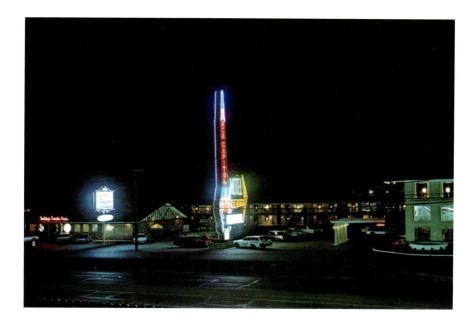

OPPOSITE, TOP: The Magic Burger stand between Attalla and Gadsden was hardly unique in drive-in culture, but its very ordinariness made it look like a relic of another time when this photo was taken in 1991. Since that time, of course, the Magic Burger has taken a bow and disappeared. *Author's collection.*

OPPOSITE, BOTTOM: Another northern Alabama chain was Shockley's Pancake Houses. They tended to cuddle up to local motels, such as the Holiday Inn and Kings Inn in Florence, the Nitefall Motel in Decatur and the Trailway Inn in Huntsville. All the locations put together would have made a not-so-short stack. *Author's collection.*

ABOVE: Here we see another Shockley's stand, making cozy with the Space Capitol Motel in—where else?—Huntsville. It appears the colorful neon rocket sign could possibly have been visible from outer space. *Author's collection.*

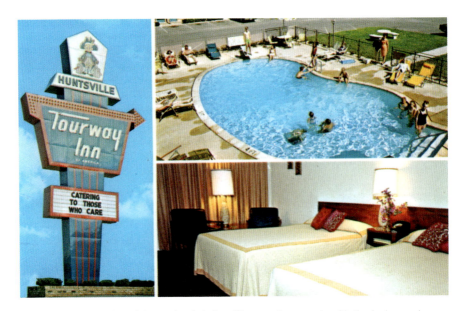

North Alabama produced the regional chain of Tourway Inn motels, with the junior-grade sea captain mascot on each sign. Tourway Inns could be found in a number of far-flung locations, even on the sands of Panama City Beach, Florida. Today, only a single example remains in Birmingham. *Author's collection.*

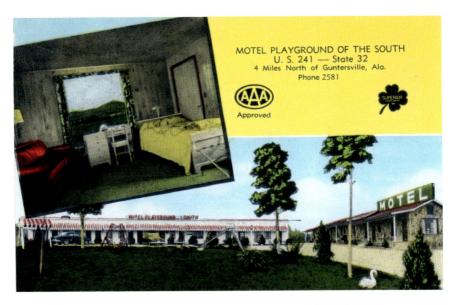

Up on Lake Guntersville, before U.S. 241 was transformed into U.S. 431, Motel Playground of the South scored points for having a most unusual type of moniker. In case anyone missed the point being made by the signage, the postcards added a new, more direct slogan: "A Very Good Motel." Who could doubt that sort of honesty? *Steve Gilmer collection.*

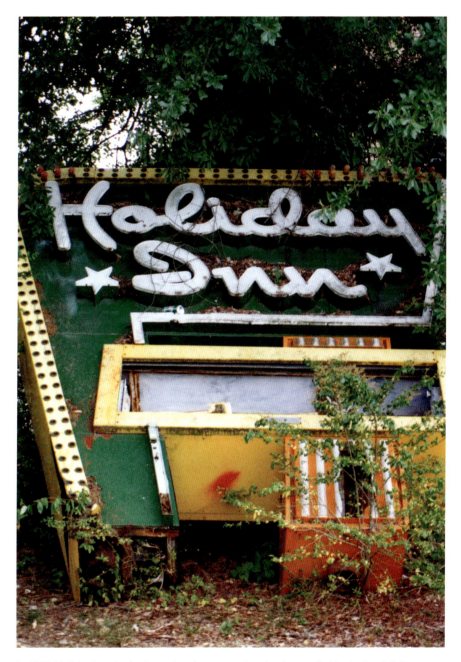

In 1983, Holiday Inn shocked travelers by announcing that it was ditching its iconic "Great Sign" that had been such a welcome nighttime sight for millions. A decade later, this discarded example—a miniature version, to be sure—rested in the trash heap behind the Holiday Inn on U.S. 78 in Hamilton. *Author's collection.*

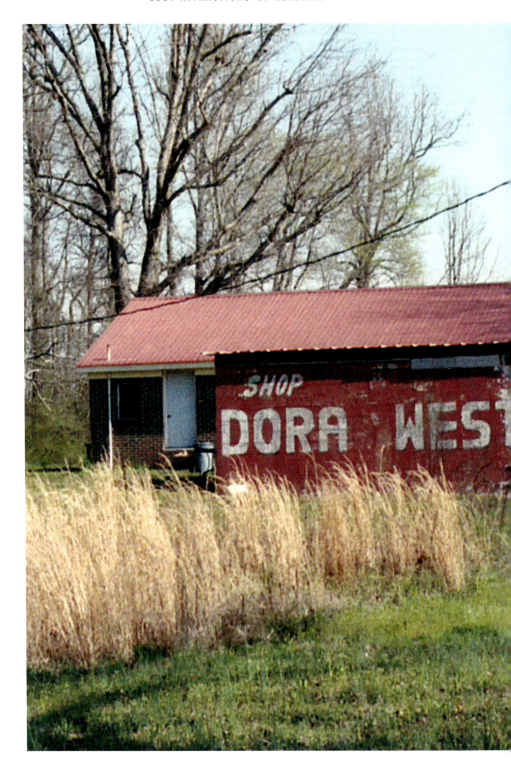

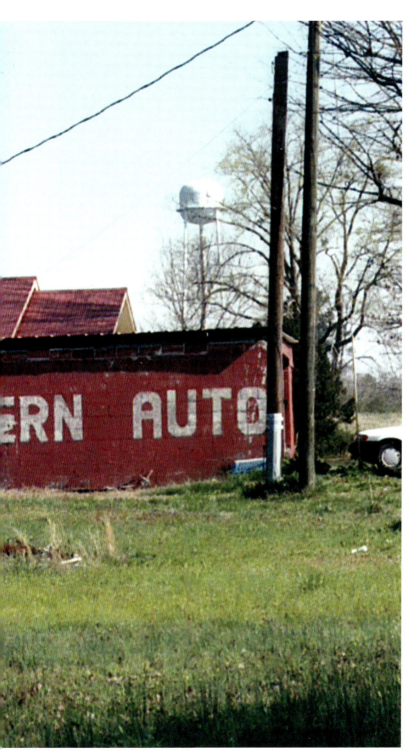

There was nothing to distinguish the Western Auto store in Dora from its many cousins in the national chain. But owner John Batson took his advertising to a different level, having "Dora Western Auto" signage painted on rooftops and sometimes even exposed rock faces along the northern Alabama highways. *Author's collection.*

About seven miles west of Dora on U.S. 78, the Alabama Snake Farm was a "throwback" type of attraction that briefly occupied a former drive-in known as the Queen of Hearts in the early 1990s. The snake farm's day seemed to have passed, and like its giant concrete cobra, it soon slithered back into the underbrush. *Author's collection.*

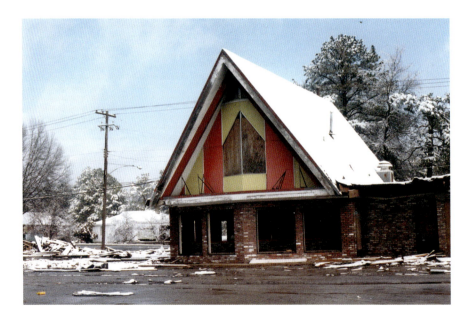

ABOVE & OPPOSITE: The chain of Sherer's Drive-Ins spread throughout northwestern Alabama and into Mississippi, with so many scattered locations that even its namesake family could not keep track of them all. A former Sherer's was always easy to identify, with an A-frame roofline and large window overlooking the parking lot. If it still sported its red and yellow stripes, as with this example being demolished in Graysville in 1987, so much the better. *Both, author's collection.*

SHERER'S

SELF-SERVICE

RESTAURANT

North of Jasper

OPEN — 8 A.M. TILL 11 P.M.
7 DAYS

- Carry Out Service
- Box Lunches
- Seat Up to 100
- Welcome All Ages

For Carry Out Service —

Call **387-1484**

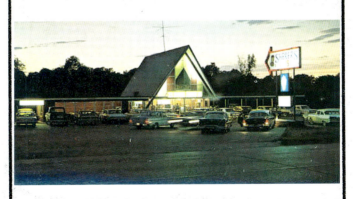

310 78 HWY BY-PASS, W.

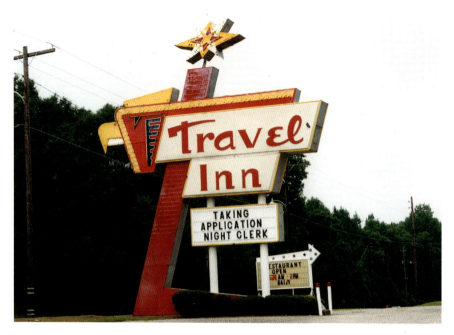

U.S. 78 between Birmingham and the Mississippi state line was the last of the major tourist routes to be bypassed by an interstate highway, in its case I-22. Before that happened, even small towns like Guin could boast impressive motel signage such as this. *Author's collection.*

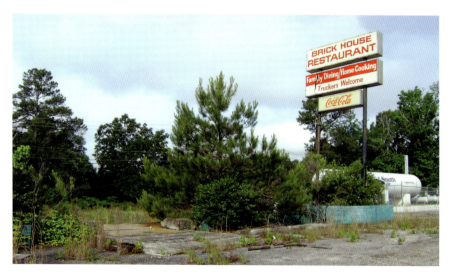

Actually, Carbon Hill's Brick House Restaurant did not even have a chance to lose its business to I-22, as it burned while U.S. 78 was still the main route to Memphis. Look closely at this spring 2018 photo, and you can even still see the door's metal threshold in the brick entranceway. *Author's collection.*

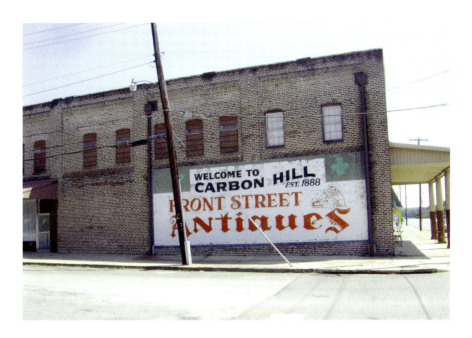

Carbon Hill was one of the hardest-hit towns on U.S. 78 when the tourist and commercial trade moved over to the interstate. The painted sign for a long-closed antique store and the ruin of an ancient Sinclair gas station are particularly poignant when juxtaposed with the empty street going past them. **ABOVE:** *author's collection*; **BELOW:** *Russell Wells collection*.

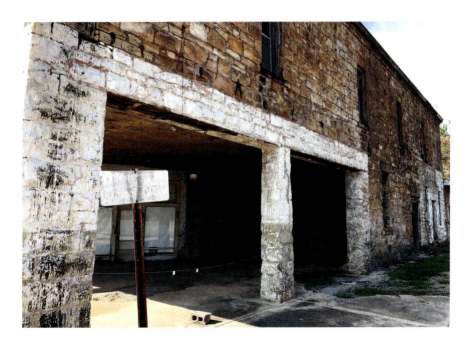

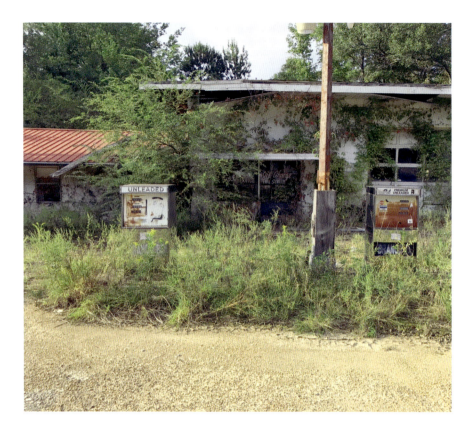

ABOVE: One good way of telling just when a gas station last operated is by the state inspection stickers on the pumps. Roadside historian Russell Wells visited what was once the bustling Suggs Truck Stop in Guin and found the most recent sticker was from 1995—the same time that a nearby stretch of I-22 opened. Today, the former Suggs pumps await traffic that will never come again. *Russell Wells collection.*

OPPOSITE: Who could resist the siren call of the American Oil Company's torch-pierced slogan, "As You Travel, Ask Us"? The slogan, and the logo, were long gone by 1983 when this remaining example was spotted perched high above the cracked pavement east of Jasper. *Author's collection.*

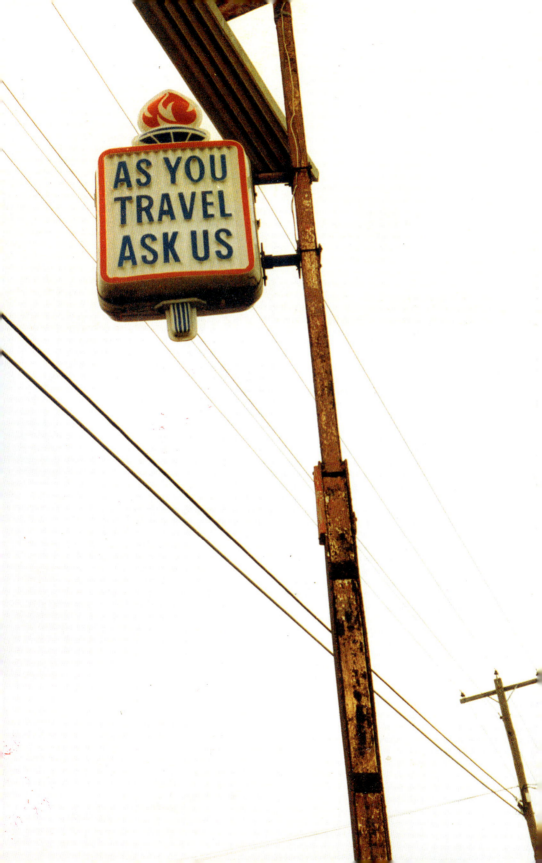

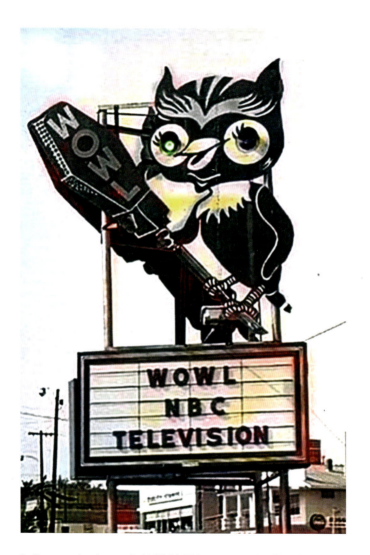

In Florence, the signage for WOWL-TV encouraged traffic safety in a different way. When there had been no traffic fatalities, the owl's green eye shone brightly. When a fatal wreck occurred, the fowl's other eye glowed an evil red. We will see another example of the same idea once we reach Birmingham in our next chapter. *Lance George collection.*

Central Alabama

IRON MEN AND NEON CONFEDERATES

Central Alabama, as it relates to this book, is bounded by Birmingham on the north and Montgomery on the south. Those two cities and the wide swath on either side of them (which also includes Tuscaloosa to the west and Auburn to the east) made this part of the state the most populous. In fact, the sprawling Birmingham metro area probably contained the greatest concentration of attractions, both past and present, of anywhere in Alabama. As the state capital, one would think Montgomery would have been a bigger tourist draw than it was; it has been observed that today's tourism industry in Montgomery is devoted to either the Civil War or the civil rights movement. Obviously, during the era of lost attractions, pretty much only one of those was a consideration.

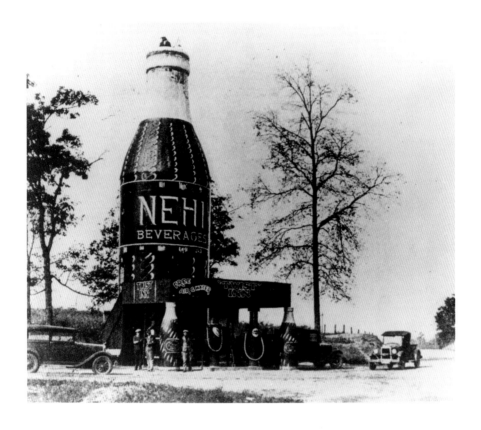

One of the state's earliest roadside attractions was this sixty-four-foot-tall bottle on what would eventually become U.S. 280, just north of Auburn. Its existence was brief—built in 1924, the wooden structure burned in 1933—but to this day, some maps still include a dot representing "The Bottle" as a location. *Auburn University Archives collection.*

OPPOSITE: Vestavia was the name given to the palatial estate built by former Birmingham mayor George Ward on U.S. 31 just south of the city. After Ward's death in 1940, his former home became a restaurant. Some historians have claimed that the murals of vestal virgins were a part of Ward's original residence, while others say they were painted as part of the restaurant's decoration. Either way, the aging structure was demolished in 1971 to make way for a church. *Both, author's collection.*

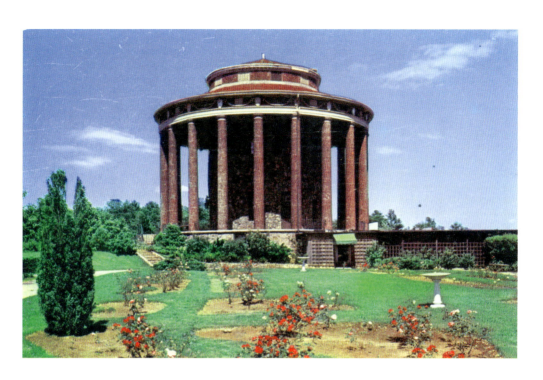

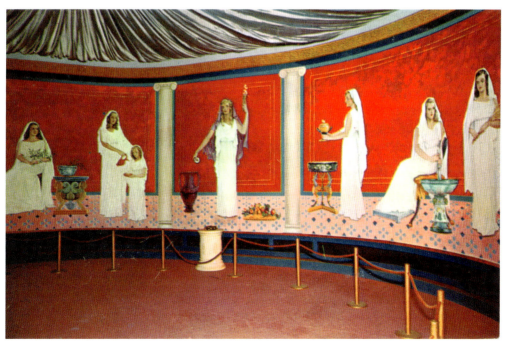

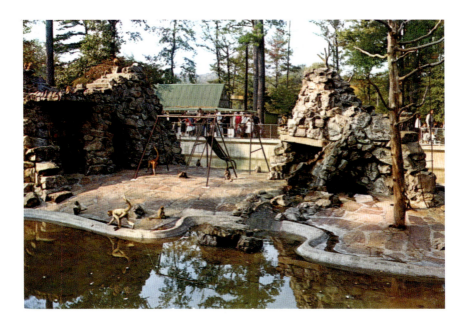

The first unit in what would grow into the sprawling Birmingham Zoo was its Monkey Island, completed in 1955. The public went bananas over the popular primates, and over the next decade, the property was filled with exhibits that, while outdated by modern animal welfare standards, had their own quirky appeal. *Author's collection.*

OPPOSITE: The Birmingham Zoo's polar bears were famous for their habit of waving at guests, in a (usually successful) attempt to get humans to toss goodies to them. The freeloading bruins could keep it up as long as anyone was paying attention. *Author's collection.*

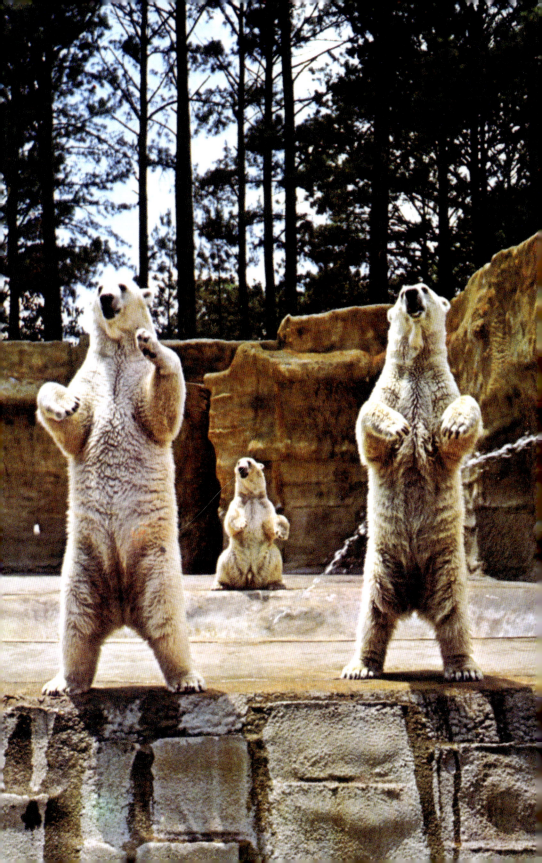

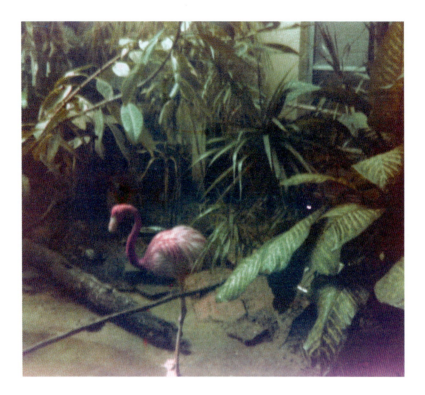

An indoor exhibit at the zoo mimicked the look and feel of a tropical rainforest. The flamingo here appears to be in the pink, but on at least some occasions, there would be a gag when zookeepers stationed a few live penguins in the rainforest just to seem clever. *Author's collection.*

OPPOSITE: The Birmingham Zoo is still one of the state's major attractions, but all except a small handful of its original 1950s-'60s features have been removed in the name of progress. The former Monkey Island was looking a bit forgotten when this photo was taken in 2009, just before it gave way to a major zoo expansion project. *Author's collection.*

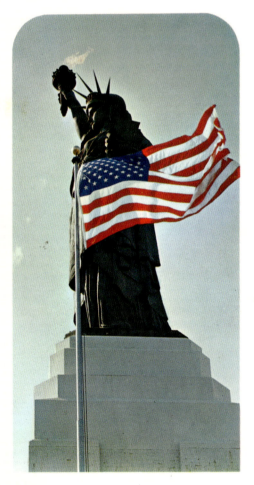

IN BIRMINGHAM

it's the

"MISS LIBERTY" TOUR

LIBERTY NATIONAL'S AWARD WINNING STATUE OF LIBERTY
Atop The Home Office Building At 301 South 20th St.

LEFT: In the early 1960s, Liberty National Insurance installed this thirty-one-foot-tall replica of the famous statue on a parapet overlooking downtown Birmingham. It replaced an earlier neon rendition of the company logo that perched atop the headquarters building. *Author's collection.*

OPPOSITE: By May 1962, Liberty National had inaugurated its "Miss Liberty Tour." Attractive tour guides known as Liberty Belles directed visitors through the two observation platforms and the Tip of the Torch Room. There, tourists could view photos of the statue's construction as well as promotional materials for Birmingham's other attractions. *Both, author's collection.*

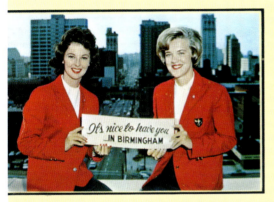

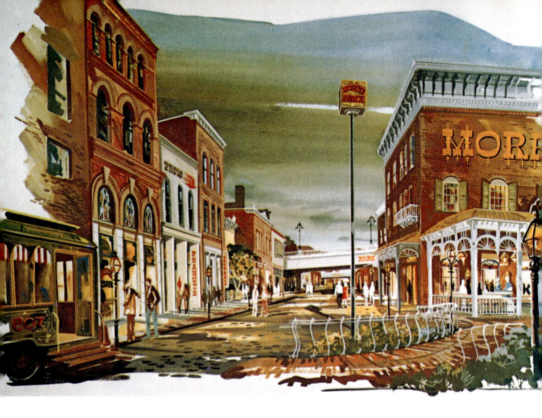

As part of the nostalgia craze that swept the nation in the mid-1970s, grand plans were unveiled to renovate one of Birmingham's oldest business districts, Morris Avenue, into a conglomeration of restaurants, nightspots and other entertainment venues. Reality never did approach the optimism of this artist's rendering, and some high crime rates in the area doomed the whole project before it could grow out of its elderly infancy. *Author's collection.*

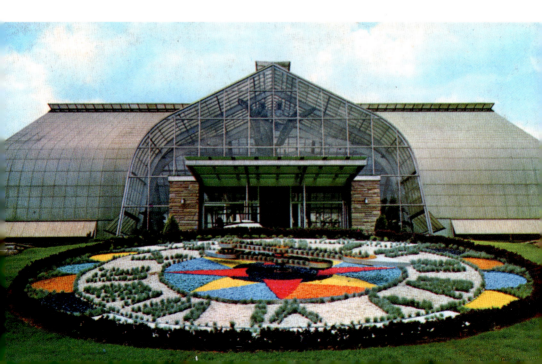

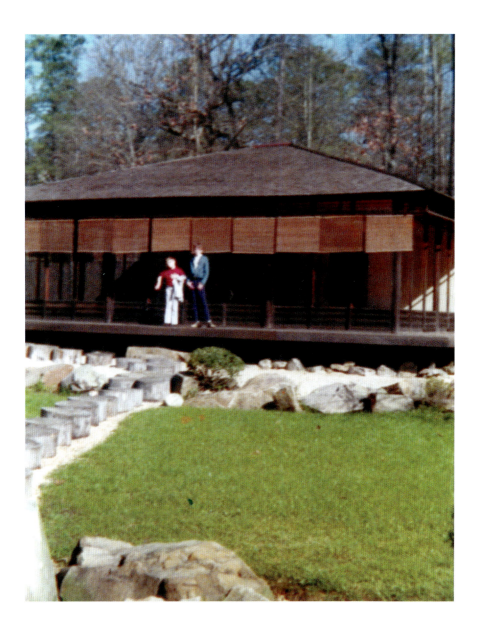

OPPOSITE, BOTTOM: One of the original features when the Birmingham Botanical Gardens opened in December 1962 was this working floral clock. Unfortunately, Father Time did his usual job on the underground clockworks, and it had to be removed in 1995. Today, the spot displays a concrete and bronze sculpture that only vaguely resembles a clock. *Author's collection.*

ABOVE: Another sight in the gardens was this teahouse, which had been part of the Japanese pavilion at the 1964–65 New York World's Fair. In Birmingham, it outlived its original purpose by some fifteen years, dismantled in 1992 and replaced with a more substantial structure. *Author's collection.*

A World of Adventure that runs on Imagination Discovery Place

LEFT: Unlike the usual scenario, Birmingham's Discovery Place children's attraction is not gone because it was not popular. On the contrary, it was so successful that in 1997 it merged with another facility, the Red Mountain Museum. The next year, the combined attractions opened as the McWane Science Center in downtown's long-closed Loveman's department store building. *Author's collection.*

OPPOSITE: Birmingham's most famous symbol was the fifty-five-foot-tall cast-iron statue of Vulcan. He had been made as the city's contribution to the 1904 St. Louis World's Fair, but by the time of this 1930s postcard, Vulcan had been assembled (incorrectly; note his right hand) at the state fairgrounds and painted to resemble a more "natural" (if that were even possible) appearance. *Author's collection.*

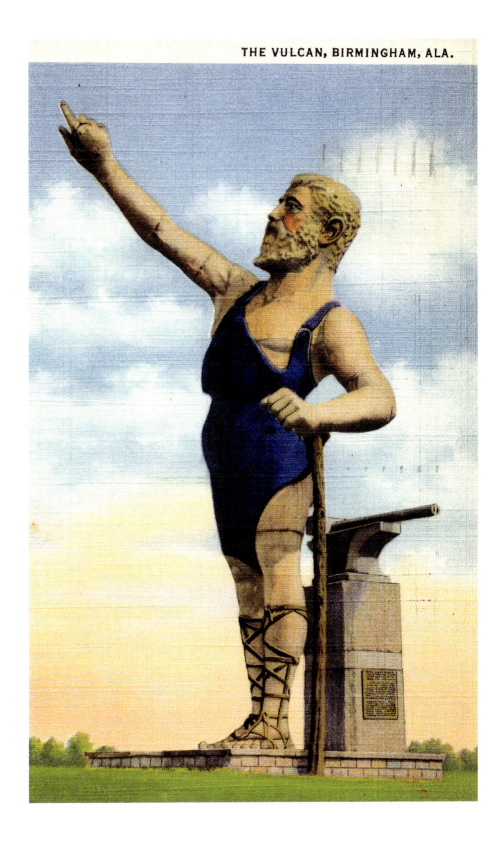

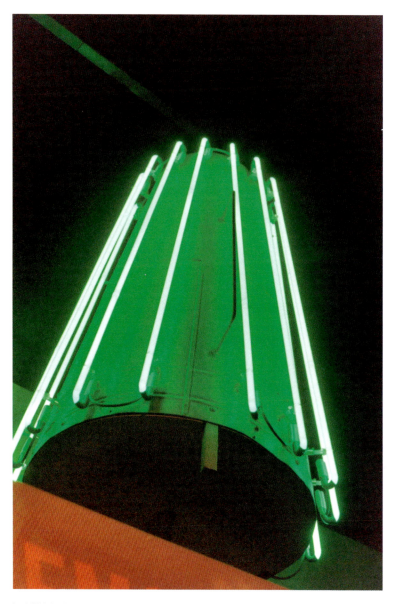

In 1939, Vulcan was placed atop a pedestal on the crest of Red Mountain. In 1946, this neon torch was placed in his right hand for a traffic safety campaign. When green, it meant there had been no traffic fatalities in the previous twenty-four hours; when red, quite the opposite. After being removed in 1999, the torch was carefully preserved in the new museum on the park grounds. *Author's collection.*

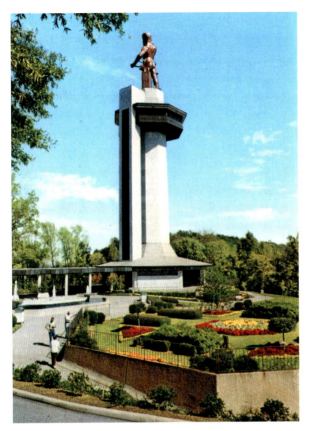

LEFT: This is how Vulcan Park appeared from 1971 until a major renovation (actually, restoration) in 1999. The marble sheath on the stone pedestal and an oversized enclosed observation deck, many felt, completely overwhelmed the Vulcan statue. Today, the park again looks much as it did in 1939, but with improvements that are not so glaringly obvious. *Author's collection.*

BELOW: Didn't we say Vulcan was Birmingham's most visible symbol? Many businesses capitalized on the name and image, including this motel on U.S. 31, just below the big iron man's perch. *Author's collection.*

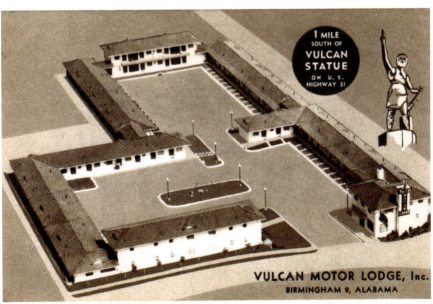

1 MILE
SOUTH OF
VULCAN STATUE
ON U.S.
HIGHWAY 31

VULCAN MOTOR LODGE, Inc.
BIRMINGHAM 9, ALABAMA

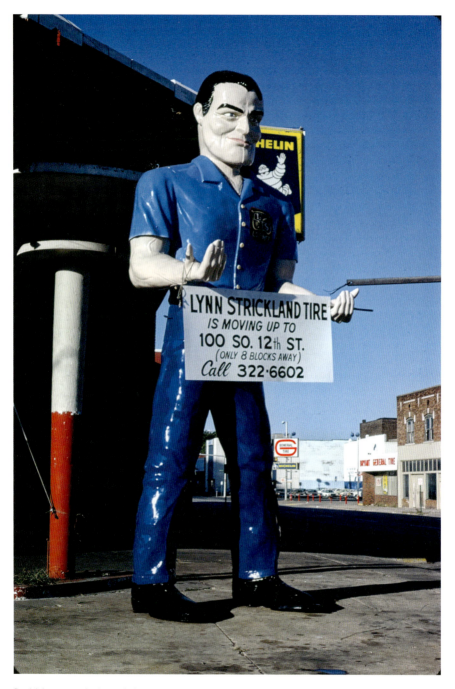

But Vulcan wasn't the only big guy hanging out in Birmingham. This "muffler man," as the lantern-jawed figures are commonly known, smiled sinisterly at passing cars on the city's south side and, later, from a rooftop alongside I-65 until felled by a storm in 1998. Currently, the big lug leers at drivers on Vanderbilt Road. *John Margolies collection.*

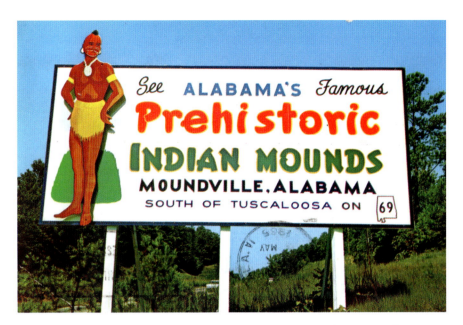

On Alabama Highway 69 south of Tuscaloosa were the mounds of Moundville. This almost too-colorful billboard stretched truth a little by calling them "prehistoric," as they dated to approximately AD 1200–1500, not contemporary with dinosaurs and cavemen. *Author's collection.*

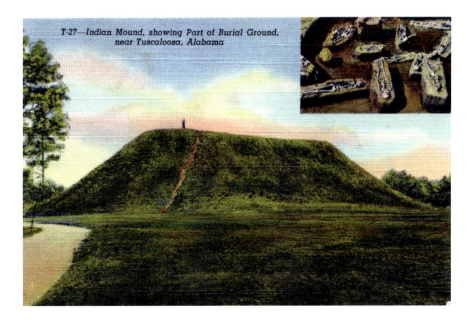

For many years, a big attraction at Moundville was the Native American skeletons, left just as they were found during excavation. Later laws prohibited such display of decayed corpses, and while presumably they are still there, people now walk on floors that hide them from view. *Author's collection.*

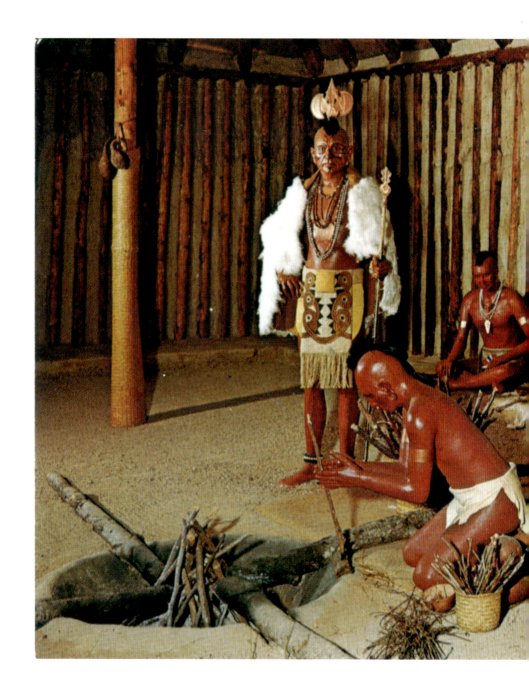

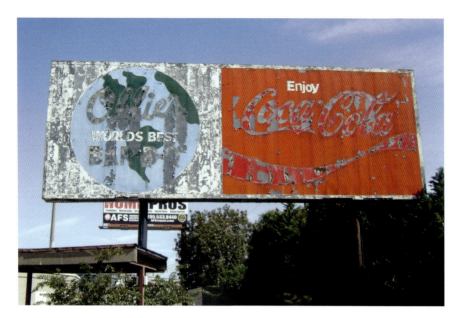

The dual Ollie's Bar-B-Q/Coca-Cola neon spectacular was a landmark on I-65 at Birmingham beginning around 1970. When the restaurant moved in 1999 and the building became a church, the Ollie's sign was painted over, but recently it has started to emerge from hiding like an undead zombie in a graveyard. *Author's collection.*

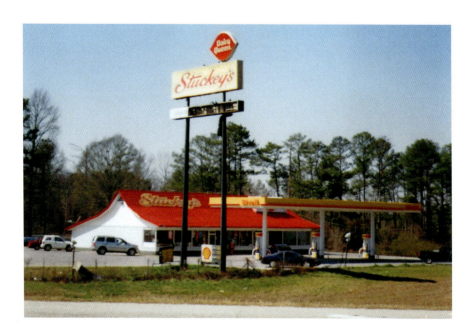

For those traveling to the beach, I-65 south of Birmingham could be a long slog indeed. One highly welcome oasis was the Stuckey's at Verbena, which helped break up the monotony. It departed the Stuckey's chain in June 2012 and became just another convenience store. *Gord Booth collection.*

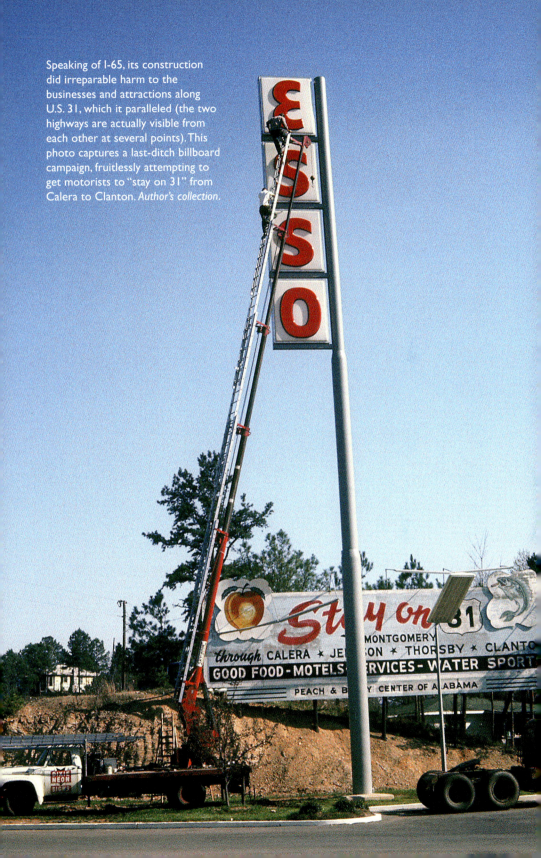

Speaking of I-65, its construction did irreparable harm to the businesses and attractions along U.S. 31, which it paralleled (the two highways are actually visible from each other at several points). This photo captures a last-ditch billboard campaign, fruitlessly attempting to get motorists to "stay on 31" from Calera to Clanton. *Author's collection.*

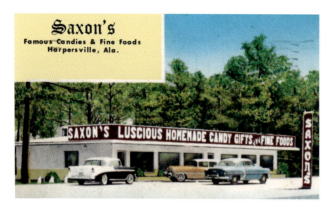

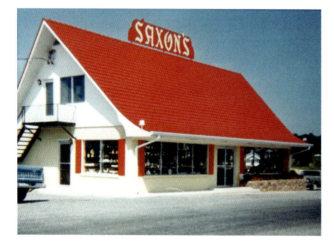

TOP: Alabama's homegrown Stuckey's impersonator, Saxon's, was well represented in the central region, especially along the routes to and from Florida. This one was at Harpersville, on U.S. 280, labeled on maps as the "Florida Short Route." Those luscious tourists headed to the Sunshine State were irresistible, and by the early 1950s, Harpersville was primarily known as one of the most notorious speed traps in the state. *Steve Gilmer collection.*

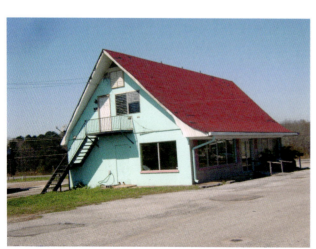

MIDDLE & BOTTOM: One of the final Saxon's stores to open was this one on U.S. 78 at Riverside, constructed in 1967. Here we see how the building appears today, remarkably unchanged throughout all of its lives since the candy and souvenirs moved out. It most recently sold tires and motorcycle parts. *Both, author's collection.*

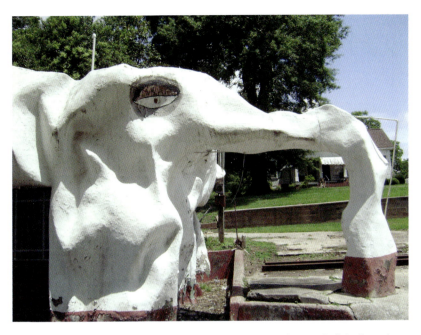

On yet another tourist route to Florida, this unusual gas station was built in Roanoke. It was originally supposed to represent a rocky sea cliff with a lighthouse on top. A later owner decided it looked like an elephant and added an eyeball. Somehow, an elephant did not seem any more incongruous in downtown Roanoke than did a sea cliff hundreds of miles from the nearest coast. *Author's collection.*

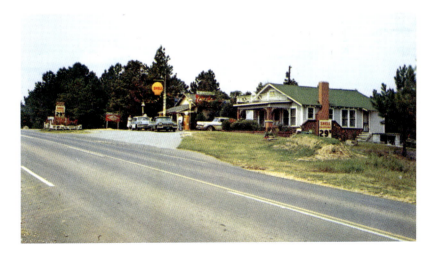

As we saw in the previous chapter, service stations were a necessary fact of life for any long-distance trip. This one at Hollins gives us all a great view of the early Shell Oil logo. *Steve Gilmer collection.*

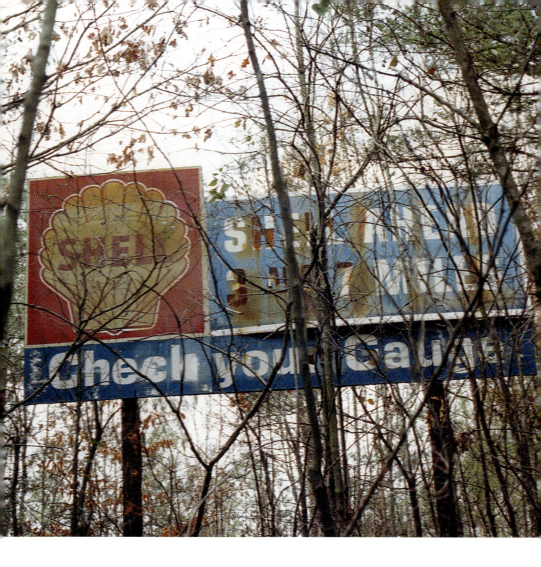

ABOVE: This Shell billboard sat forgotten among the foliage alongside U.S. 78 at Graysville in the 1980s. The site it occupied is now the interchange of 78 and I-22. *Author's collection.*

OPPOSITE: Another common logo seen along the highways until the early 1970s was the blue-and-white Pure Oil sign. The example at Sam's Café could be found at the intersection of major highways U.S. 80 and 43 at Demopolis; the abandoned remnant of Pure's red neon arrow sat alongside U.S. 280. **OPPOSITE, TOP:** *Steve Gilmer collection;* **OPPOSITE, BOTTOM:** *author's collection.*

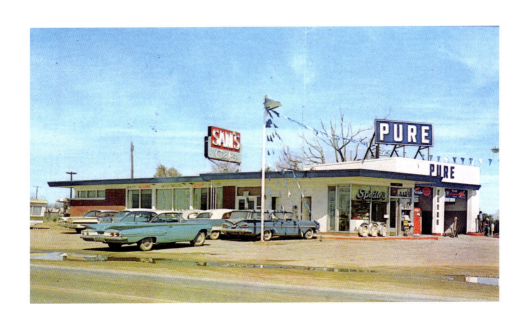

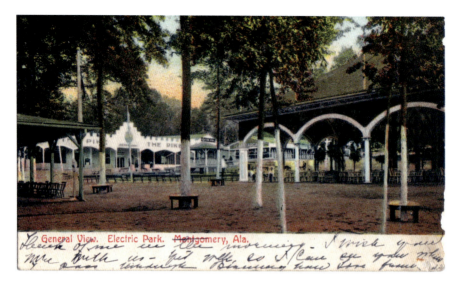

The history of amusement parks in central Alabama is full of lost attractions. This postcard of Electric Park in Montgomery was mailed in 1907. It was typical for the era—a collection of rides and pavilions at the end of a streetcar line. As the name suggested, the mere use of electricity was a large part of its appeal. *Author's collection.*

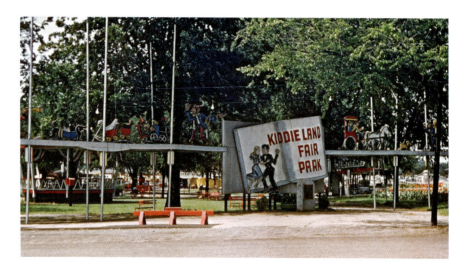

In 1947, the city of Birmingham opened its Kiddieland Park at the state fairgrounds on U.S. 11. Whereas electricity had been a novelty forty years earlier, Kiddieland was surrounded by flashy neon signage. *Author's collection.*

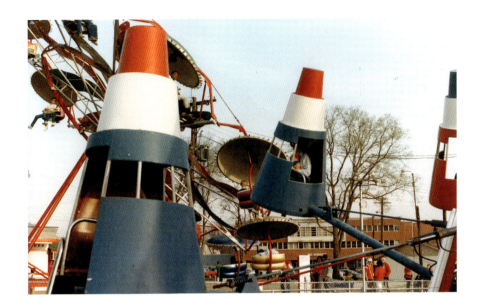

Kiddieland survived in much its original form until around 1985, when a remodeling program removed all of its vintage features. In the carousel photo, note the neon signage for the Comet Jr. roller coaster in the background and the colorful stripes of the bumper-cars pavilion in the upper left-hand corner. That pavilion was the longtime survivor of the park, sitting vacant until the property was cleared to build Birmingham's new sports complex in 2009. *Both, Cariss Dooley collection.*

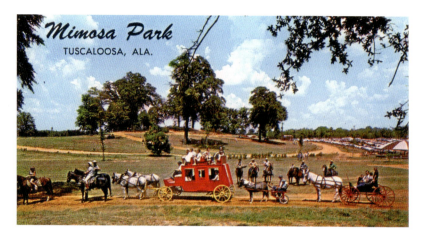

It seems that Mimosa Park in Tuscaloosa has been completely forgotten by area historians, even though the city still has a street designated as Mimosa Park Road. Little is known except that Mimosa Park contained a recreation of a Western town, complete with a general store and the stagecoach ride seen here. *Lance George collection.*

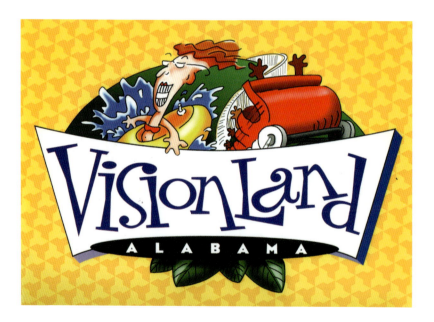

One of the biggest debacles in Alabama amusement park history was the opening of VisionLand near Bessemer in May 1998. Its graffiti-like logo did nothing to help draw tourists, and Alabamians continued to travel to Georgia, Tennessee and Florida for their theme park needs. After many ownership changes, the former VisionLand operates today as Alabama Splash Adventure and has apparently finally found the success that eluded it in its original format. *Author's collection.*

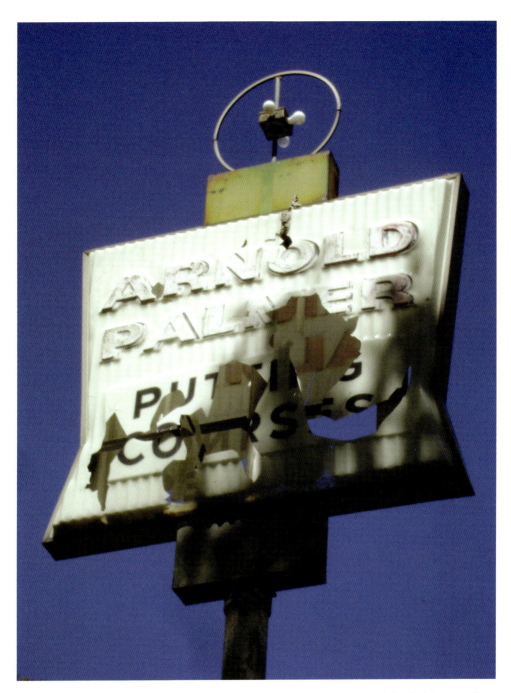

Without a trace of irony, champion golfer Arnold Palmer loaned his name to a chain of miniature golf courses in the early 1970s. Birmingham had one of those, but by 2010, its abandoned signage was in the rough. The property has since been cleared for low-cost housing. *Author's collection.*

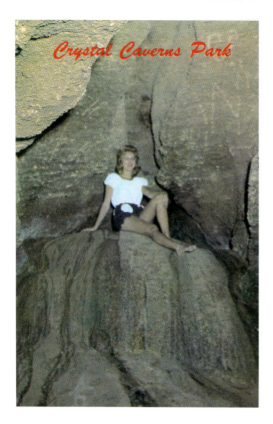

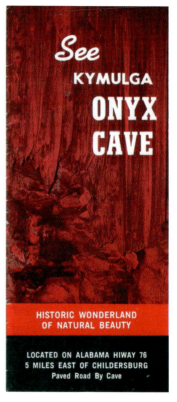

TOP, LEFT: Yet another now-closed cave attraction was Crystal Caverns Park, near the town of Clay. It advertised being Alabama's oldest commercial caverns, first opened to the public in 1927. In this postcard, it appears that Daisy Mae has wandered over from her normal home in Dogpatch, USA. *Author's collection.*

TOP, RIGHT: Surely you've heard of KyMulga Onyx Cave, right? No? You've seen its dozens of billboards along all the central Alabama highways, haven't you? Still doesn't sound familiar? Maybe that's because in 1976 it changed its name to DeSoto Caverns; under that name it definitely does not qualify as a lost attraction. *Author's collection.*

OPPOSITE, TOP: How would it have looked if Rock City Gardens had been located in central Alabama instead of near Chattanooga? Probably a lot like Bama Rock Garden on U.S. 11 at Vance. Although closed for years, there is a movement to restore and reopen Bama Rock Garden as a Tuscaloosa city park. Hold on to your boulders, and we'll all see what happens. *Author's collection.*

OPPOSITE, BOTTOM: The Hungry Fisherman was a seafood chain owned by the same company as Shoney's and Captain D's. Its Birmingham location was advertised with this billboard on U.S. 280. Even though that busy highway was rerouted years ago, the fading Hungry Fisherman artifact became something of a landmark along the older two-lane route. That fisherman must be nearly starved by now. *Author's collection.*

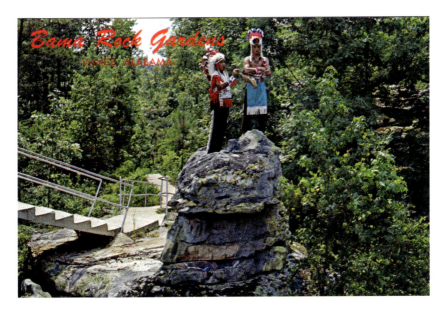

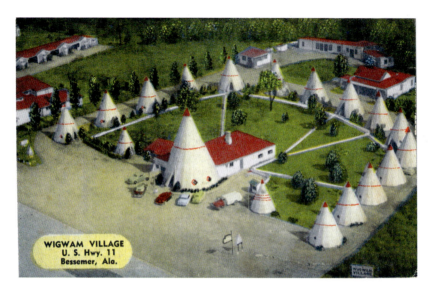

We now take a look at some of the notable motels that made central Alabama their home, and none is more famous to roadside historians than the Wigwam Village on U.S. 11 at Bessemer. It opened in 1940 as part of a chain based in Cave City, Kentucky. Even though it closed in the early 1960s, the concrete tepees stayed around long enough to create a lasting memory for travelers. *Author's collection.*

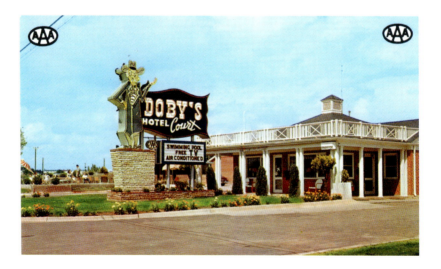

The Wigwam Village stood out by looking misplaced, but that cannot be said for Doby's Hotel Court in Montgomery. One suspects that the neon Senator Claghorn look-alike on the sign represented everything that could possibly be connected with the unreconstructed Southland. *Author's collection.*

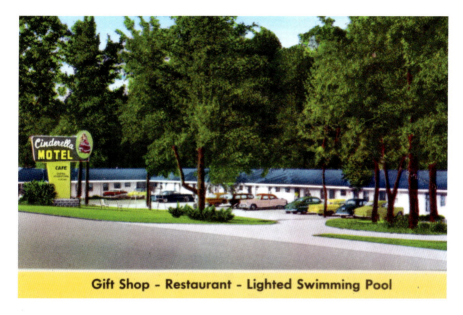

Gift Shop - Restaurant - Lighted Swimming Pool

The Cinderella Motel at Prattville reminds us all of comedian Archie Campbell's astute observation: "If you ever go to a bancy fall and wanna meet a pransome hince, don't forget to slop yer dripper." *Author's collection.*

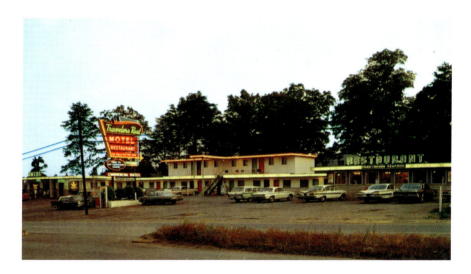

In the 1960s, U.S. 78 between Birmingham and Graysville could be a dark, lonely drive after dark. About halfway through the ordeal, the Traveler's Rest Motel pierced the night with seemingly miles of varicolored neon. The motel is still there, but the neon and its locally famed restaurant are not. *Warren Reed collection.*

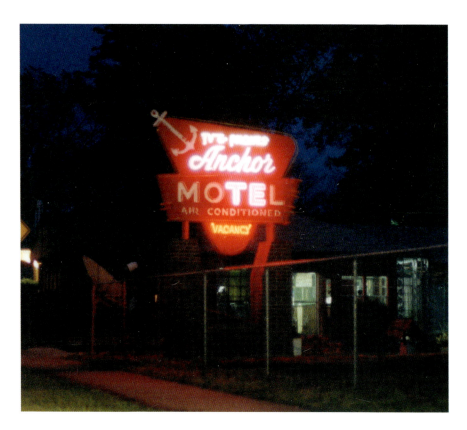

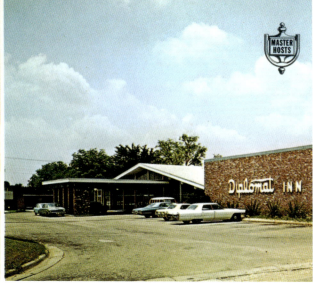

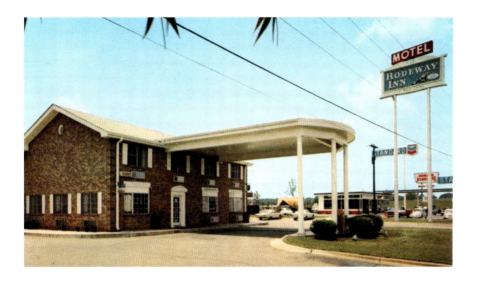

OPPOSITE, TOP: On the other side of Birmingham, as U.S. 78 snaked east toward Atlanta, another burst of neon heralded the Anchor Motel. This is another example of a name not befitting its location, which of course was nowhere near any body of water that would accommodate an anchor—neon or not. *Author's collection.*

OPPOSITE, BOTTOM: The Diplomat Inn on the south side of Montgomery no doubt took its name from the politicians it hoped to attract among its clientele. Its postcards, though, chose to emphasize the long, tall bikini mom you see here instead of some Boss Hogg–type senator. *Author's collection.*

ABOVE: Now, what about a motel that was totally unremarkable except that the signage around it brings back all sorts of fond memories? Look closely at the Rodeway Inn on West South Boulevard in Montgomery and you will also see the classic Standard Oil gas station sign, and the even more nostalgic orange roof of a Howard Johnson's Motor Lodge. *Author's collection.*

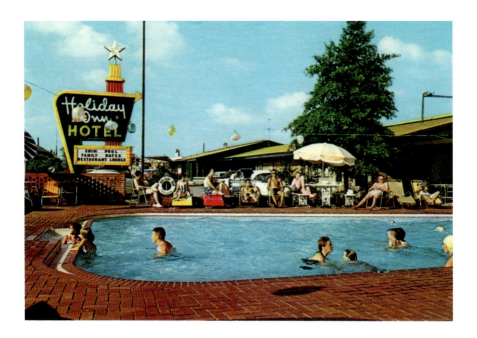

ABOVE: Seeing a need for quality lodging for the many steel magnates who were attracted to Birmingham's industrial sites, in 1954 Richard Hail Brown opened Alabama's first Holiday Inn on U.S. 11, also known as the Bessemer Superhighway. Early brochures show that Brown's Holiday Inn was literally a one-stop shop, with everything from a restaurant to a library to a pharmacy to a service station on the premises. For entertainment, Brown even had a bowling alley (Holiday Bowl) and a miniature golf course next door. *Author's collection.*

OPPOSITE: Farther down U.S. 11, near Woodstock, Richard Hail Brown opened Holiday Beach, another attraction named in honor of his association with Holiday Inn. *Mike Cowart collection.*

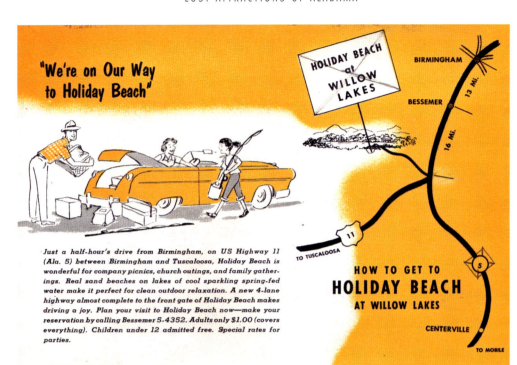

"We're on Our Way to Holiday Beach"

Just a half-hour's drive from Birmingham, on US Highway 11 (Ala. 5) between Birmingham and Tuscaloosa, Holiday Beach is wonderful for company picnics, church outings, and family gatherings. Real sand beaches on lakes of cool sparkling spring-fed water make it perfect for clean outdoor relaxation. A new 4-lane highway almost complete to the front gate of Holiday Beach makes driving a joy. Plan your visit to Holiday Beach now—make your reservation by calling Bessemer 5-4352. Adults only $1.00 (covers everything). Children under 12 admitted free. Special rates for parties.

HOW TO GET TO HOLIDAY BEACH AT WILLOW LAKES

Here's What HOLIDAY BEACH Offers You

(at Willow Lakes)

Family Fun! Fun for Sister, Brother, Mom and Dad; clean, healthful, outdoor fun for everyone. In the wholesome atmosphere of Holiday Beach, you're sure to find your pleasure preference. Play on the clean, sandy beach of spring-fed Willow Lakes; swim or fish in sparkling clear waters; hike in the scenic woodlands; or simply relax with family or friends in the sunny comfort of Holiday Beach. Dance, if you like, or enjoy delicious Holiday Beach barbecue. Perfect for a fun-filled afternoon or an all-day family outing, Holiday Beach offers a complete variety of outdoor recreation.

FUN FOR ALL • Outstanding Recreation Facilities

- Baseball
- Badminton
- Tennis
- Volley Ball
- Shuffle Board
- Horse Shoes
- Swimming
- Boating
- Real Sand Beaches for Lounging
- Picnic Tables and Pits—Finest Food Facilities
- Fishing
- Croquet
- Games

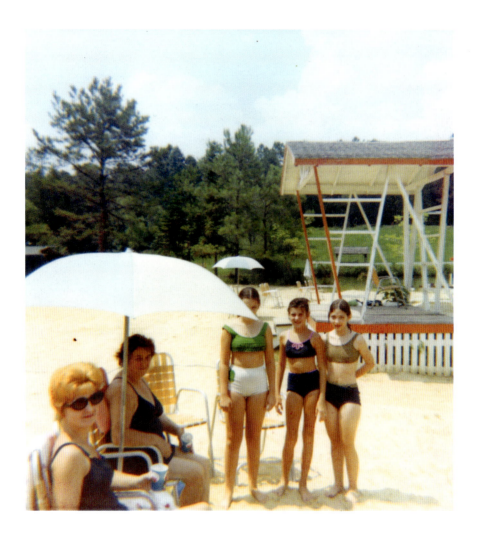

ABOVE: One fact proven over and over was that Alabamians loved the beach, but many in the northern and central regions had neither the time nor ready cash to make a trip to the coast very often. For them, and many others, "manufactured" beaches such as Holiday Beach were the solution. *Cariss Dooley collection.*

OPPOSITE: Yet another artificial coastline was Castaway Islands Beach Resort, on Lake Martin at Eclectic. These postcards show that it truly leaped feetfirst into the mini–theme park world, with its miniature railroad and kiddie stagecoach rides among its many attractions. As with so many other former parks, its name now survives on maps merely as a road. *Both, author's collection.*

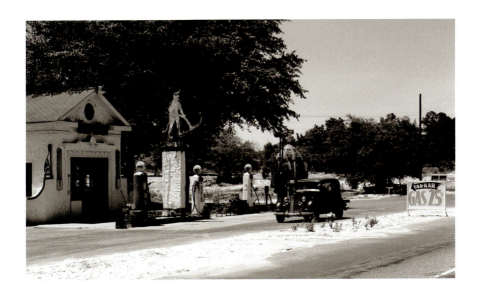

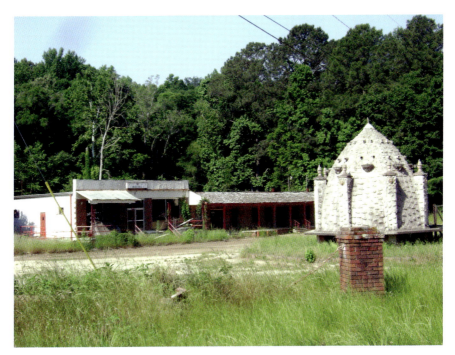

Today, Red Devil Lake's beehive fountain sits in its original location in what appears to be an overgrown parking lot. A variety of businesses have operated in the buildings in the background, but motorists' attention is inevitably drawn to the former fountain, every bit as out of place as it appears. *Author's collection.*

Southern Alabama

EMBATTLED BEACHES AND
BEACHED BATTLESHIPS

In the overall picture of American tourism, Alabama was primarily a state that people passed through on the way to their true destination—and that usually meant Florida. Similarly, the southern third of the state seemed to exist mostly for people from other parts of Alabama who were headed for the beach. For many, that meant the Miracle Strip of Florida's panhandle, but as those resorts grew more crowded and commercialized, many tourists elected to remain on Alabama's own short Gulf Coast. Today, the two coastal counties of Mobile and Baldwin contribute nearly 40 percent of the total tourism spending in Alabama. In this, our final chapter, we will see some of the businesses that attempted to siphon off a few dollars before those tourists managed to reach the beach.

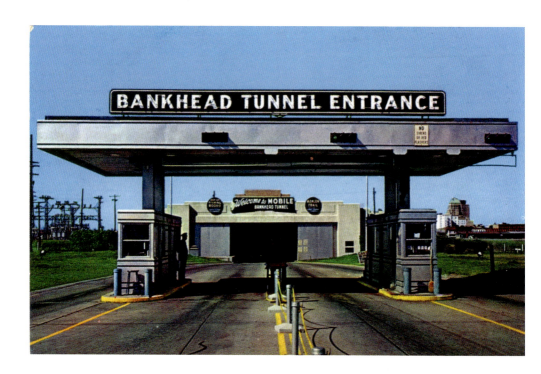

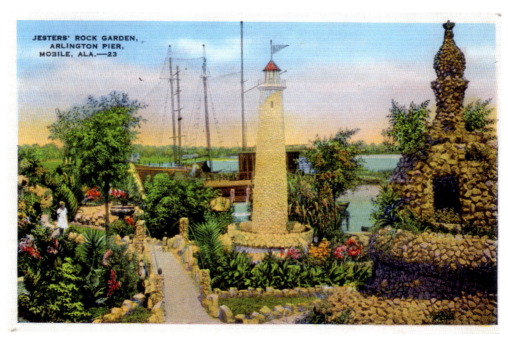

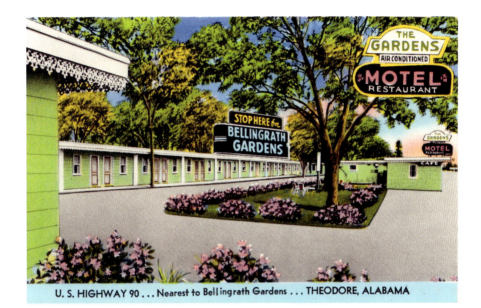

U. S. HIGHWAY 90 . . . Nearest to Bellingrath Gardens . . . THEODORE, ALABAMA

OPPOSITE, TOP: It goes without saying that the 1941 Bankhead Tunnel is hardly a lost attraction, but those who choose to drive through it are no longer confronted by this marquee-like neon display. Also, following the signage for U.S. 90 today will divert one around the city rather than directly through the tunnel. *Steve Gilmer collection.*

OPPOSITE, BOTTOM: Postcards from the 1930s identify this amazing collection of sculptures as Jesters Rock Garden in Mobile's Arlington Park (aka Arlington Pier). What became of it seems to be unrecorded history, but an aerial view of today's Arlington Park shows no traces of this rocky fairyland. *Steve Gilmer collection.*

ABOVE: No doubt the oldest surviving man-made attraction in the Mobile area is Bellingrath Gardens, dating back to 1932. The gardens are still blooming, but the same cannot be said for the lavish neon signage of this motel, which sought to graft itself onto Bellingrath's flowering popularity. *Author's collection.*

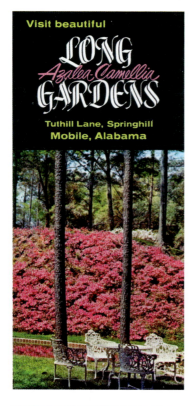

Visit beautiful

Long
Azalea-Camellia
Gardens

Tuthill Lane, Springhill
Mobile, Alabama

One might think that an attraction such as Bellingrath Gardens would be powerful enough to discourage any competition. No one has a patent on azaleas—or any other flowers, for that matter—so Long Gardens staked out its own beautiful little plot. Long's time was short, however, and last reports are that the former property sits neglected and overgrown. *Both, author's collection.*

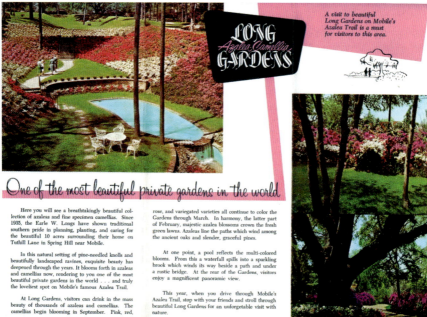

Long
Azalea-Camellia
Gardens

A visit to beautiful Long Gardens on Mobile's Azalea Trail is a must for visitors to this area.

One of the most beautiful private gardens in the world

Here you will see a breathtakingly beautiful collection of azaleas and fine specimen camellias. Since 1935, the Earle W. Longs have shown traditional southern pride in planning, planting, and caring for the beautiful 10 acres surrounding their home on Tuthill Lane in Spring Hill near Mobile.

In this natural setting of pine-needled knolls and beautifully landscaped ravines, exquisite beauty has deepened through the years. It blooms forth in azaleas and camellias now, rendering to you one of the most beautiful private gardens in the world . . . and truly the loveliest spot on Mobile's famous Azalea Trail.

At Long Gardens, visitors can drink in the mass beauty of thousands of azaleas and camellias. The camellias begin blooming in September. Pink, red,

rose, and variegated varieties all continue to color the Gardens through March. In harmony, the latter part of February, majestic azalea blossoms crown the fresh green lawns. Azaleas line the paths which wind among the ancient oaks and slender, graceful pines.

At one point, a pool reflects the multi-colored blooms. From this a waterfall spills into a sparkling brook which winds its way beside a path and under a rustic bridge. At the rear of the Gardens, visitors enjoy a magnificent panoramic view.

This year, when you drive through Mobile's Azalea Trail, stop with your friends and stroll through beautiful Long Gardens for an unforgetable visit with nature.

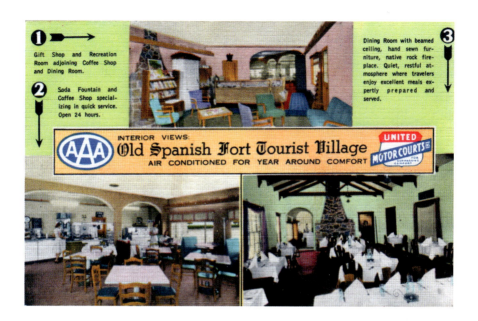

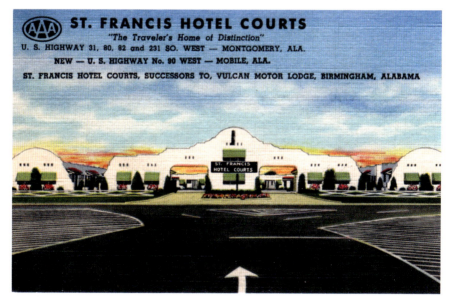

At least two different motels/tourist courts subscribed to the Spanish theme of the Gulf Coast's history. Old Spanish Fort was one of those, like the early Holiday Inns, that promised all the amenities of a small town. The St. Francis Hotel Courts, with its mission-style architecture that it shared with the larger Alamo Plaza motels, was part of a chain, with other outposts in Birmingham and Montgomery. *Both, author's collection.*

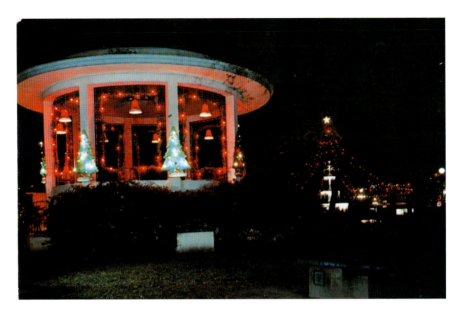

Hopefully, Christmas will never become a lost attraction, but there have definitely been changing tastes in how to celebrate it. This view of Mobile's Bienville Square certainly evokes an era of downtown decorations we will likely never see again. *Steve Gilmer collection.*

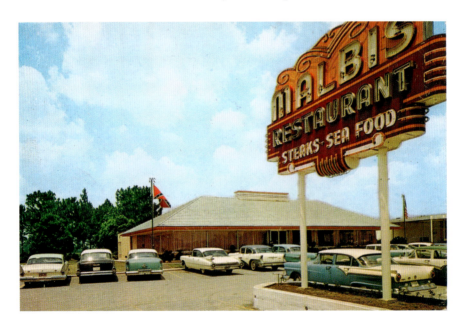

Roussos RESTAURANT

Your Host:
The Roussos Family

Each MEMBER of the Roussos family is dedicated to your enjoyment while you are our guest. Our intention is that you will remember your visit as a pleasant and satisfying experience.

The Ancient Mariner secret: your order is especially prepared to your liking by skilled chefs to assure you the best of flavor and service.

"Your Satisfaction

is

Our Reputation"

ON BATTLESHIP PARKWAY -- 1 MILE EAST OF BATTLESHIP ALABAMA

Family Restaurant

The Best Steaks in Town

Gathering Place

The Best Seafood in Town

OPPOSITE, BOTTOM & ABOVE: Naturally, most restaurants along the coast emphasized their seafood specialties. The Malbis Restaurant sign must have been a sight to see when illuminated at night; Rousso's has existed in more than one form over the years, but the location the ancient mariner was advertising here was wiped out by Hurricane Frederic in 1979. OPPOSITE, BOTTOM: *Steve Gilmer collection;* ABOVE: *author's collection.*

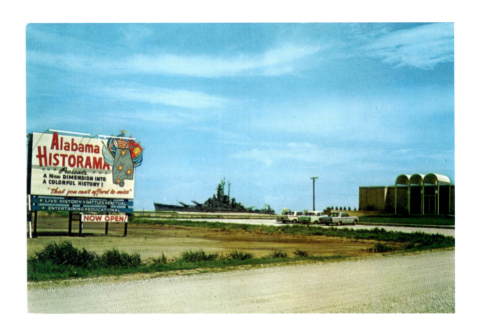

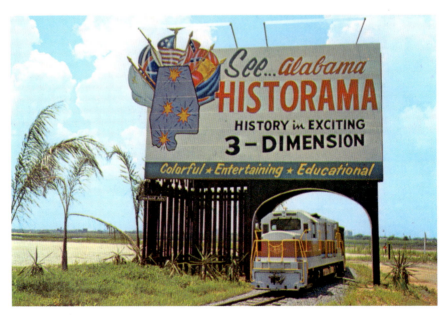

Along with Bellingrath Gardens, Mobile's tourist industry is famous for the preserved World War II battleship USS *Alabama*. Its thousands of visitors quite unknowingly pass the site of the more obscure Alabama Historama, which in the 1960s sat next to the titanic ship's entrance drive. **TOP:** *author's collection*; **BOTTOM:** *Steve Gilmer collection*.

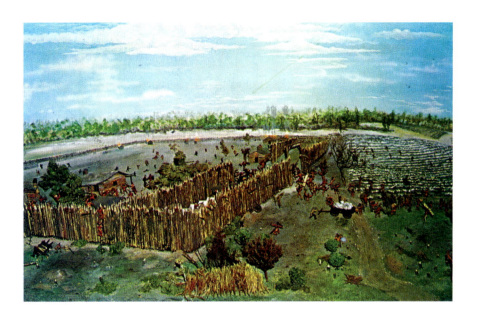

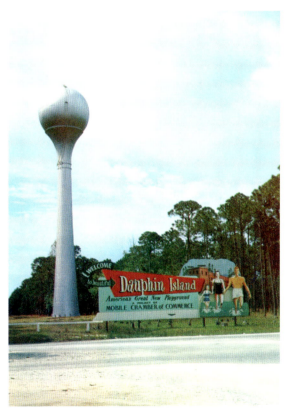

ABOVE: Inside, the Alabama Historama greatly resembled attractions such as the Horseshoe Bend diorama we saw in the previous chapter. Episodes from the state's history were enacted by miniature actors; this one represented the infamous massacre at Fort Mims, where the Creek tribe failed to put out the welcome mat for the settlers. *Author's collection.*

LEFT: In 1954, a three-mile-long bridge opened to connect the mainland with Dauphin Island, the barrier where the only beaches in the immediate Mobile area could be found. About ten years later, this was the colorful sight greeting motorists as they drove into the island. *Author's collection.*

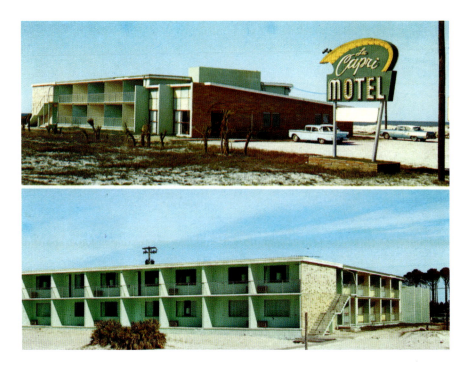

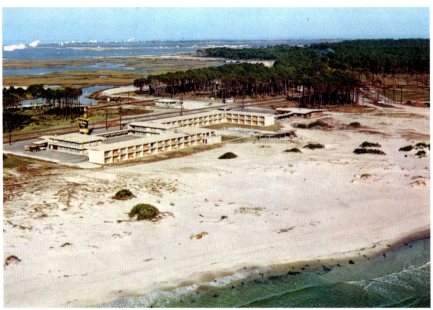

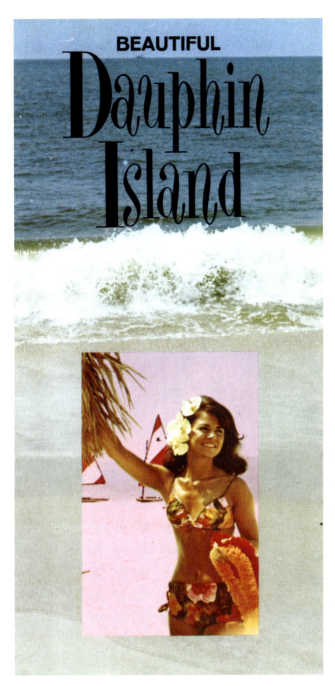

OPPOSITE: Once Dauphin Island was opened for general tourism, it did not take long for motels, both large and small, to sprout from the white sands like sea oats. The tiny La Capri is where this author's family stayed during our first beach visit in 1966; Holiday Inn had also recognized Dauphin Island's potential, building there before the 1950s were even over. *Both, author's collection.*

LEFT: This is a mighty attractive brochure, but somehow one gets the feeling that, along the way, some tourism promoter got Dauphin Island confused with Hawaii. The beautiful model they used looked like she could have come straight out of *Alabama 5-O. Author's collection.*

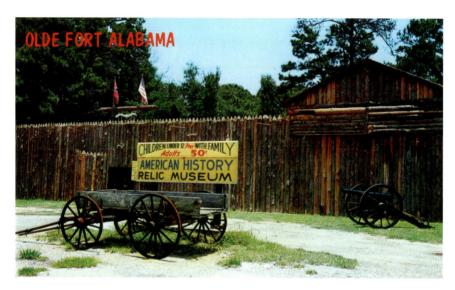

Motels and fishing were the primary lures of Dauphin Island, but there were a few other small attractions. This American History Relic Museum tried to add some education to the area's normal recreation. Like the rest of Alabama's gulf region, Dauphin Island was devastated by Hurricane Fredric in 1979, and several other storms since then have further reshaped its coastline. The La Capri and Holiday Inn are now part of the same history the Relic Museum attempted to preserve. *Author's collection.*

Fishing supplies manufacturer Tom Mann had his own attraction, Mann's Fish World, on U.S. 431 near Eufaula beginning in the late 1960s. The star was Mann's pet largemouth bass, Leroy Brown—no doubt the baddest fish in the whole Mann town. *Author's collection.*

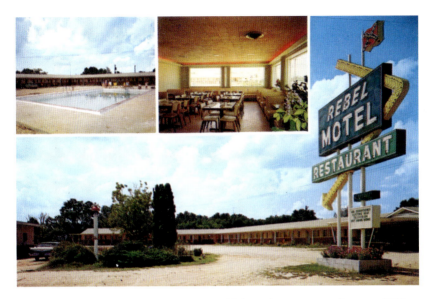

Elsewhere in Eufaula, it was plain to see that old times there were not forgotten. With its name and neon Confederate flag, the Rebel Motel set out to prove it wasn't just whistling Dixie, son. *Steve Gilmer collection.*

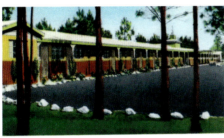

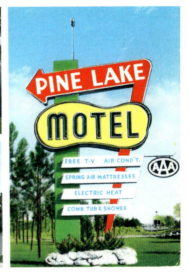

If travelers were headed for the white sand and goofy attractions of Florida's Miracle Strip, the two most traveled highways south of Montgomery were U.S. 231 and U.S. 331. Until recently, when it gained new ownership, a new name and much more boring signage, the Pine Lake Motel on 231 was a much-anticipated sight on the road to the beach. Its adjoining outlet of the Saxon's chain had turned off the lights much longer ago. *Author's collection.*

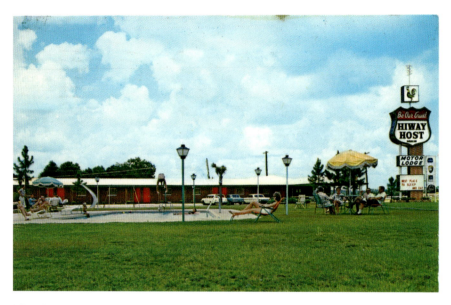

Hiway Host was the motel chain begun by Richard Hail Brown after he ended his association with Holiday Inn. Its giant U.S. highway shield signage made a Hiway Host easy to spot, such as this one in Troy. *Author's collection.*

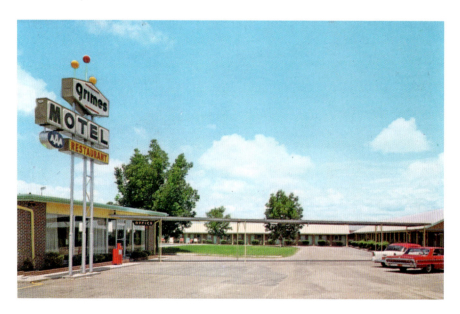

Also on U.S. 231 in Troy, the Grimes Motel certainly did not look grimy in its postcard views. Those three colored balls above the sign were a common 1960s embellishment whose practical function was nonexistent. *Author's collection.*

As we have seen, most of the A-frame locations of the Sherer's Drive-In chain were in northwestern Alabama and into Mississippi. There was at least one remote outlet in Ozark, however, and over the years it has undergone a staggering number of paint jobs to match its changing identities. *Author's collection.*

If one were traveling on U.S. 331 instead, there was not a whole lot to see between Montgomery and Opp, by which point one was pretty close to the Florida state line. This view of 331 as the main drag through Luverne is full of now-lost businesses, including a Ben Franklin dime store and a Red and White grocery. *Author's collection.*

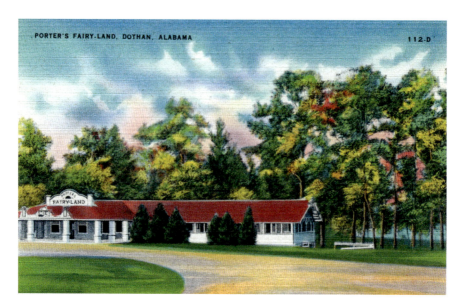

At Dothan, Porter's Fairy-Land was not another park with recreations of famous bedtime stories. Instead, it was yet another combination pavilion and swimming hole. Apparently, having the real beach only about sixty miles south was not enough for some people. *Steve Gilmer collection.*

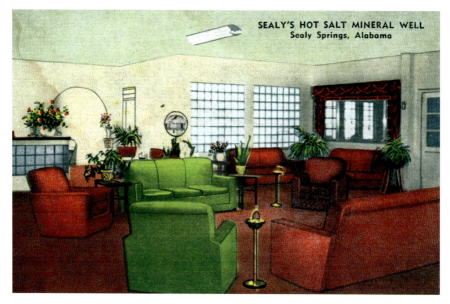

Like Hepsidam in the Bankhead Forest, Sealy Springs is another community that does not appear on most modern maps. Near Cottondale, it was about as far south as one could travel before hitting Florida. *Author's collection.*

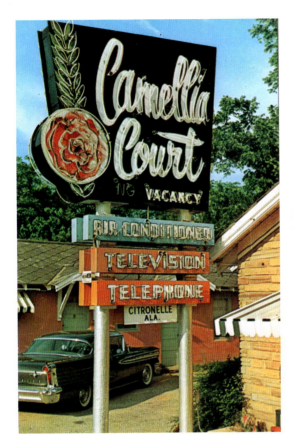

LEFT: As you may know, the camellia is Alabama's state flower. This motel at Citronelle must have had access to one blooming genius when it came time to build its neon sign. Oh, to be able to see that one at night! *Author's collection.*

BELOW: Stuckey's came to Alabama in 1953, and this store at Loxley was probably its first in the state. At that time, nearly every Stuckey's featured the same pink walls and painted mural advertising cold orange juice. *Michael Smith collection.*

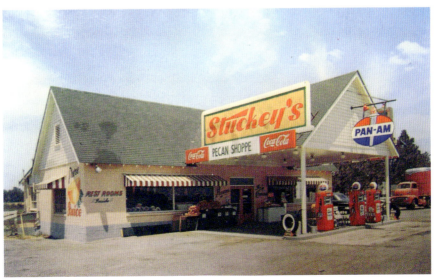

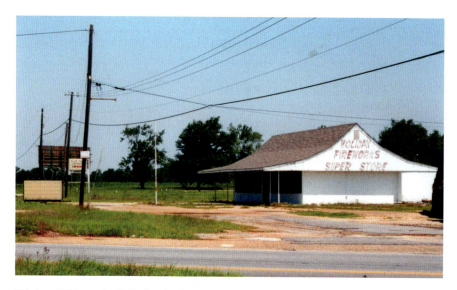

This late 1950s–early 1960s Stuckey's building design was at Dothan. The location remained in business into the 1970s. Like most of its brethren, it sat on the right-hand side of the road (in this case, U.S. 231) heading away from Florida, as tourists were more likely to buy candy and souvenirs as they headed for home at the end of their trip. *Author's collection.*

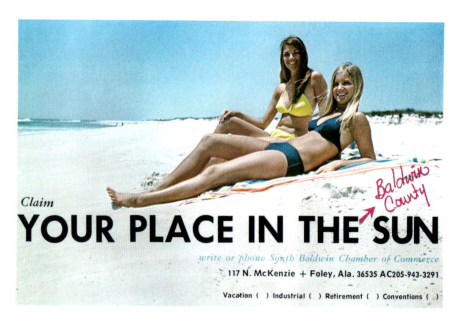

If southbound tourists were not headed for Florida, it was Alabama's stretch of Gulf Coast that was their goal. This advertisement was from the South Baldwin County Chamber of Commerce. *Author's collection.*

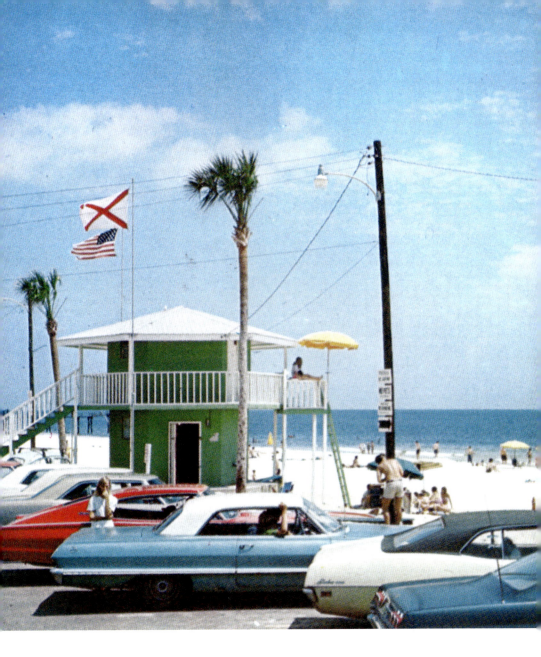

Alabama had established its Gulf State Park as early as 1935, but it was on Independence Day 1949 that Governor Jim Folsom officially opened the Gulf Highway, an eleven-mile stretch that would finally encourage tourism along the coastline. *Author's collection.*

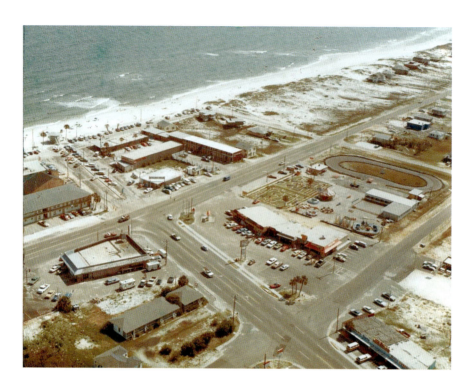

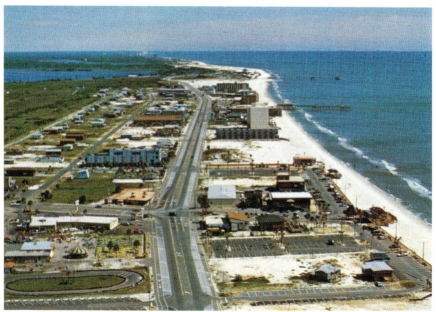

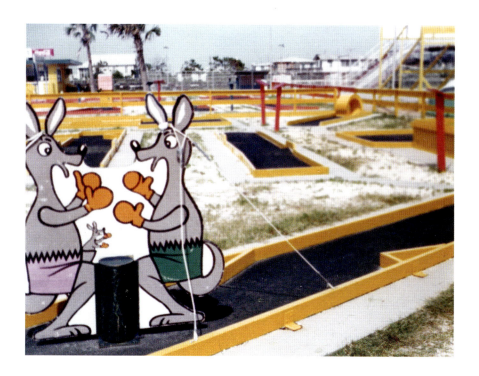

OPPOSITE: By the mid-1960s, there was no question that Gulf Shores was the centerpiece of Alabama's beach industry. These two incredible aerial views show that tourist town from different angles, one facing south and the other facing east. Visible in both is a miniature golf course with adjacent go-kart track and amusement rides, plus many small motels and cottages and an unlimited choice of souvenir shops and restaurants. This is pretty much how things looked until September 1979, when Hurricane Frederic wiped the slate (and beach) clean, making way for today's high-rise condo development. **OPPOSITE, TOP:** *Gulf Shores Museum collection;* **OPPOSITE, BOTTOM:** *J.D. Weeks collection.*

ABOVE: Here is how that mini-golf seen in both aerial views appeared at ground level. It was remarkably simple, but then again, those were remarkably simpler times on Alabama's coast. *Author's collection.*

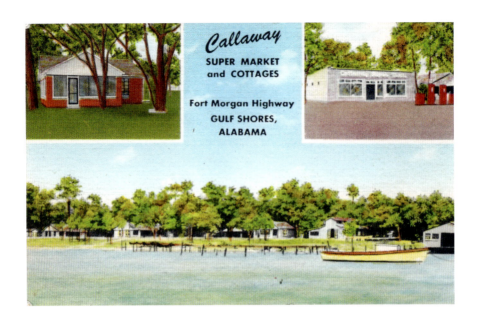

Lodging was also at its most basic in pre-1970s Gulf Shores. Callaway Super Market and Cottages was a prime example of the early days. The sky-blue Sunnyland Cottages was where this author's family spent a night or two in 1967, but it could just as well have been in 1950, considering how much things had stayed the same. TOP: *Steve Gilmer collection*; BOTTOM: *author's collection*.

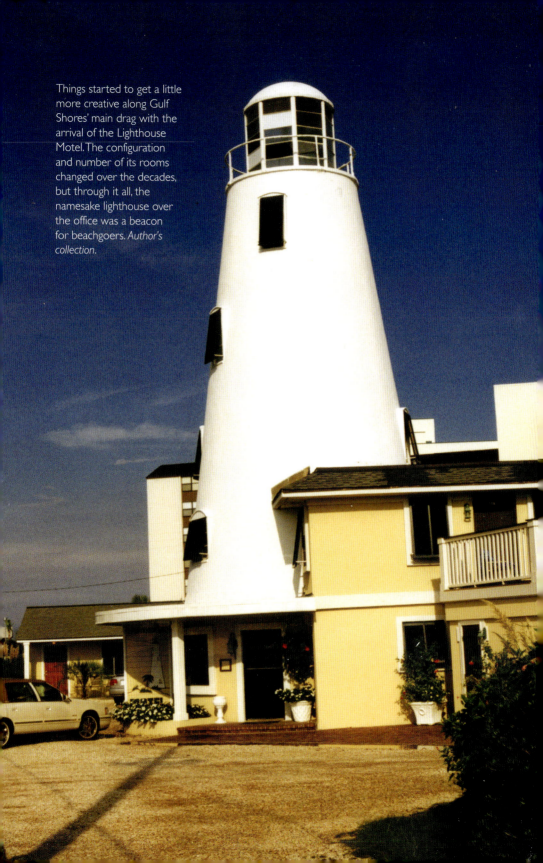

Things started to get a little more creative along Gulf Shores' main drag with the arrival of the Lighthouse Motel. The configuration and number of its rooms changed over the decades, but through it all, the namesake lighthouse over the office was a beacon for beachgoers. *Author's collection.*

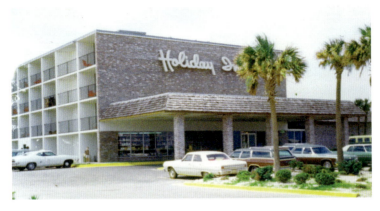

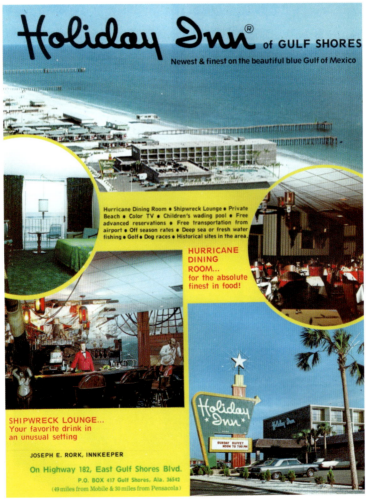

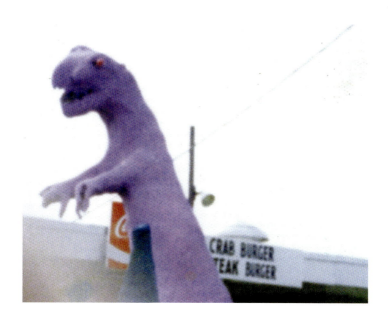

OPPOSITE: When Holiday Inn saw fit to raise its flashing "Great Sign" above Gulf Shores in 1970, it showed that a true resort was in the making. With its four (count 'em, four!) floors, it towered over its tiny cinder-block motel neighbors. *Both, author's collection.*

ABOVE: Just a few feet east of the Lighthouse Motel, this somewhat deformed purple dinosaur—no, Barney had not been created yet—welcomed everyone to a miniature golf course that was called Spooky Golf on its sign, but Surfside Golf on its scorecards. Either name would have been equally fitting. *Author's collection.*

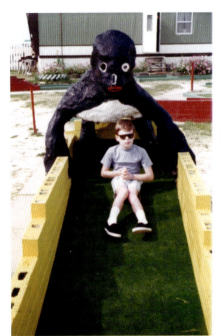
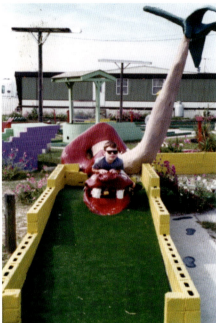

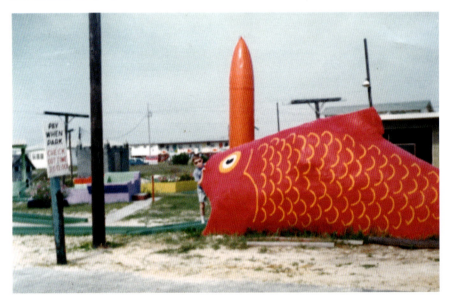

This trio of family album photos illustrates your author's visit to Spooky (née Surfside) Golf in 1973. While he hides behind his sunglasses, you can marvel at the gloriously homemade appearance of the course's obstacles and other props. Some, including the giant fish and snake, were unapologetically patterned after figures at Panama City Beach's Goofy Golf, while others appeared to have no previous counterparts. *All, author's collection.*

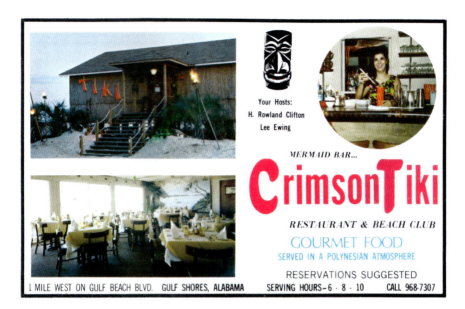

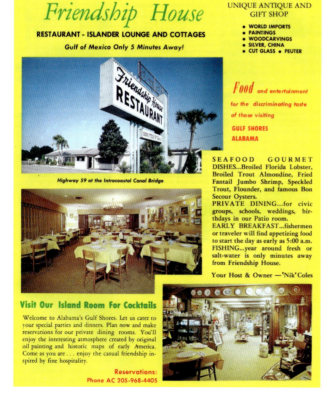

ABOVE: For no particularly good reason, the Polynesian/South Seas theme was immensely popular along the Gulf of Mexico coastline. Gulf Shores' Crimson Tiki restaurant was only one of dozens of such businesses. Eventually, instead of seeming novel, they simply fit right in as much as the waves breaking on the sand. *Author's collection.*

LEFT: There were several Friendship House restaurants along the Gulf Coast. The one at Gulf Shores ("Gulf of Mexico only five minutes away!") was distinguished by its associated gift and antiques shop. *Author's collection.*

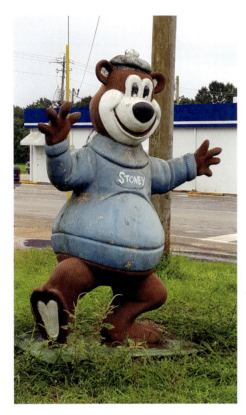

LEFT: Writer Kelly Kazek discovered this unusual relic along one of southern Alabama's roadsides. No, his name was not originally Stoney, as printed on his sweater. In a former life, this was the Great Root Bear, the jolly mascot of the A&W Drive-In chain. *Kelly Kazek collection.*

BELOW: And now we finally come down to what might have been Alabama's most famous lost attraction. The ruins of Styx River Water World at Loxley became far more famous among roadside history buffs than the water park had ever been while open. *Dean Jeffrey collection.*

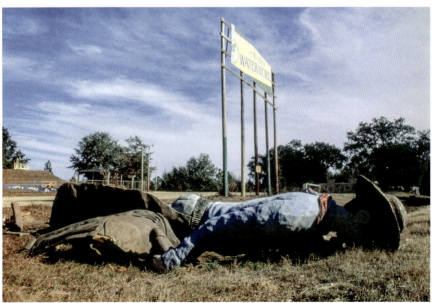

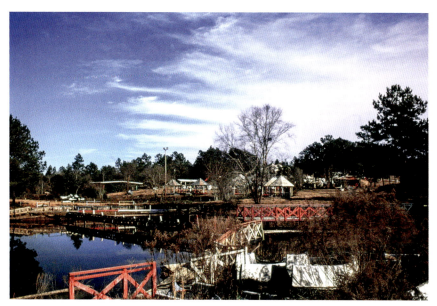

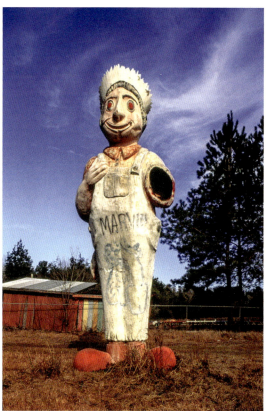

For many years after it closed, curious visitors would find their way onto the Styx River Water World property to take photos such as these. It was littered with park remnants and an enviable collection of fiberglass figures, many of unknown lineage. The property has since been totally cleared, and now even the lost attraction of Styx River has left no trace of its former existence. *Both, Dean Jeffrey collection.*

BIBLIOGRAPHY

BOOKS AND ARTICLES

Birmingham News. "Folsom Opens Gulf Highway on the Fourth." June 16, 1949.

———. "Harpersville Speed Trap Broken Up." February 17, 1952.

Bolton, Mike. "All that's Left of the Bottle Is the Name." *Birmingham News*, undated clipping.

Drinnon, Elizabeth McCants. *Stuckey: The Biography of Williamson Sylvester Stuckey*. Macon, GA: Mercer University Press, 1997.

Gadsden Times. "Little River Canyon Rides Open Tomorrow." March 7, 1970.

Hollis, Tim. *Dixie Before Disney: 100 Years of Roadside Fun*. Jackson: University Press of Mississippi, 1999.

———. *See Alabama First: The Story of Alabama Tourism*. Charleston, SC: The History Press, 2013.

———. *Stuckey's*. Charleston, SC: Arcadia Publishing, 2017.

Huntsville Times. "New Management Will Run VisionLand." February 11, 2000.

———. "Space City Projects Big Amusement Park." January 19, 1964.

Jackson, Harvey H., III. *The Rise and Decline of the Redneck Riviera: An Insider's History of the Florida-Alabama Coast*. Athens: University of Georgia Press, 2012.

Malone, Becky. "KyMulga Cave Could Become Major Tourist Attraction." *Talladega Daily Home*, August 14, 1969.

Morris, Philip A. *Vulcan and His Times*. Birmingham, AL: Birmingham Historical Society, 1995.

Osborn, Clement. "Alabama's Canyon Booming Tourist Attraction." *DeKalb News*, July 4, 1971.

Satterfield, Carolyn Green. *The Birmingham Botanical Society: A Brief History*. Birmingham, AL: Birmingham Botanical Society, 1999.

Simms, Jimmy. "Looney's Tavern: The Legacy." *Cullman Times*, June 10, 1998.

Storey, Debroah. "Space City, Amusement Park Proposed in 1960s, Was Never Completed." *Huntsville Times*, March 18, 2012.

This Is Alabama. Montgomery, AL: State Division of Records and Reports, 1946.

WEBSITES

www.alabama.travel

www.archives.alabama.gov

www.bbgardens.org

www.birminghamrewound.com

www.birminghamzoo.com

www.dauphinisland.org

www.encyclopediaofalabama.org

www.gulfshores.com

www.moundville.ua.edu

www.roadsideamerica.com

www.stuckeys.com

www.visitvulcan.com

ABOUT THE AUTHOR

Author and Alabama native Tim Hollis has written thirty-two books on pop culture history, a number of them concerning southeastern tourism. His 2013 book *See Alabama First* tells the history of the state's tourism industry, but this is the first to concentrate solely on the defunct tourist businesses of Alabama.

Visit us at

www.historypress.com